MAJOR ARCANA

Portraits of
Witches in America

Frances F. Denny

Andrews McMeel
PUBLISHING®

FOREWORD

Pam Grossman

I confess I was a bit wary when Frances reached out to request I sit for a portrait for *Major Arcana: Witches in America*. As someone who has identified as a witch for most of her life, I was used to piquing people's curiosity. Yet my experiences of being put on display to exemplify someone else's idea of what a witch is hadn't always gone well.

Frances, however, understands that the image of myself as a witch and the image of myself as a person are interlinked. No matter which of these aspects is being emphasized to the public, I want to be sure that I'm represented as multi-dimensional and powerful on my own terms. After speaking with her at our initial meeting, I felt assured that Frances wasn't looking to frame me as a freak or a fetishized femme fatale. Her approach is to depict modern witches as wholly self-possessed individuals. She realizes that the expression of my magic and the depiction of my personhood needed to be as integrated in her photographs as they are in my own identity.

Both Frances and I believe that every photograph of a woman or female-presenting individual has the potential to chip away at the wall of sexism that's been constructed over centuries. As a photographer, Frances has built up a

riveting body of work that centers the female experience without exploiting it or trivializing it. That she has now decided to focus her camera on witches is particularly significant, for in doing so she is excavating the history of female imagery construction at its very foundations.

It can be argued that the image of the witch is one of the earliest examples of widespread propaganda against women. Though beliefs and stories about witches have existed in virtually every culture throughout history, the hyper-sexed, homicidal, Satan-worshipping witch as we know her came to prominence in fifteenth-century Europe. Friars of various sects of the Catholic church traveled throughout western Europe to warn villagers that bewitching, bedeviled dames dwelled among them, but it was the advent of the printing press that caused these ideas—and, crucially, images—about witches to proliferate and spread to the masses.

Heinrich Kramer's *Malleus Maleficarum* (or *The Hammer of Witches*) of 1486 stated that although anyone could be a witch, women were far more likely than men to fall prey to Satan's persuasive tactics due to their innate gullibility, weakness, and insatiable carnality. Texts like this one not only "informed" people about the existence of nefarious witches, but many included visual renderings that showed them shape-shifting into animals, attacking unwitting neighbors with weather magic or weaponry, and happily swooning in the devil's embrace. Their hair was often shown loose and uncovered, and they rode the skies with cooking forks, brooms, or other phallic stand-ins between their legs. Artists of the age such as Albrecht Dürer and Hans Baldung Grien were inspired by these tomes and took things a step further by drawing witches that gathered in the nude to make all sorts of trouble. Their artworks were collected by wealthy men and kept in back rooms or curiosity cabinets for private titillation.

Over the next 200 years, witch-hunting manuals and pamphlets circulated throughout Europe and, eventually, the New England colonies. Tragically, this anti-witch crusade cost tens of thousands of people their lives over the next several centuries, and scholars estimate that between 75–85 percent of those accused were women. Though it's anachronistic to apply film critic Laura

Mulvey's "male gaze" terminology of the 1970s to sixteenth- and seventeenth-century witch hunting, it's fair to point out that it was exclusively men who were authoring and illustrating the books that popularized the notion of depraved—and usually female—witches. And it was women who paid the price for it.

Since the nineteenth century, however, the word "witch" has taken on positive and often feminist connotations. Undoubtedly, Hollywood films such as MGM's *The Wizard of Oz* of 1939, the post-war British "Pagan Revival," and the subsequent mid-twentieth-century birth of the modern religion of Wicca had a huge hand in its resignification. So, too, did the rise of women across societal strata. For who better to symbolize a subversive, feminine force than the marginalized, magical witch?

It is through this historical lens—pardon the pun—that Frances's remarkable photographs are best viewed. Her pictures of modern witches offer a respectful, anthropological, and quite beautiful glimpse into a complex spiritual and political movement. But they also pull double duty in depicting these women and genderqueer individuals as subjects and not objects, thereby decoupling both feminine imagery and witch imagery from their centuries-old baggage of straight cis-male desire, fear, and control.

Some of these witches are sexy, but they are never objectified. Some might be shadowy, but they are never posed to shock. A photograph is, by nature, a flattened, two-dimensional picture forever frozen in time. And yet somehow, Frances's series feels nuanced and fully formed, as does each witch within it. Individually, each subject comes across like their own craft-master and knowing guide who has graciously welcomed us into their sacred space.

This was certainly the intention. When Frances invited me to participate in this project, what she was really doing was inviting me to invite her. I was told I could wear whatever I felt most comfortable in and to choose a location that felt right to me—which was, in my case, my home. When Frances arrived, she was curious, kind, and unimposing, while still deftly making use of natural light and artful angles. She managed to make my Brooklyn apartment feel suspended between

worlds yet totally grounded. And she made me feel, well, enchanting and sincerely myself.

Taken as a whole, Frances's pictures reveal a diverse and complex spectrum of contemporary witchery. Those who sat for her camera vary in practice and style, background and lived experience. Some of us are rather open about our witchcraft as we navigate our daily lives and shape our digital personas. For others, this was the first time they identified as a witch in public, but they trusted Frances as I did, for they too felt she would handle their image with care.

Together, these portraits form an eclectic visual coven that includes many different reflections of what it means to be a witch and how to truly represent female-led meaning-making. What those of us fortunate enough to be initiated into it share is a stance of strength, searching, and self-empowerment.

Witches might interface with invisible entities of whatever name we choose to call them. But in rendering us more visible, Frances has furthered our fight against patriarchal constraints and spiritual oppression. She's cast a circle of change with the snap of a shutter.

And if that's not magic, I don't know what is.

Pam Grossman is the creator and host of The Witch Wave *podcast and the author of* Waking the Witch: Reflections on Women, Magic, and Power *(Gallery Books) and* What Is a Witch *(Tin Can Forest Press). Her writing has appeared in such outlets as the* New York Times, *the* Atlantic, TIME, Ms. Magazine, *and her occulture blog,* Phantasmaphile. *She is cofounder of the Occult Humanities Conference at NYU and has been called "the Terry Gross of witches" (*New York Magazine*).*

AUTHOR'S NOTE

Modern witchcraft comprises a vast landscape, home to many varying opinions and politics. These portraits and accompanying textual accounts represent the topography of that landscape. The opinions reflected herein are the subjects' own.

I collaborated closely with my subjects to delineate the hows, wheres, and whats of each portrait. As much as logistically possible, they selected the location of their photo shoot, and they chose their attire (or lack thereof) with the notion that these choices would reflect something about their practice of witchcraft. At the beginning of each shoot, we sat for an informal interview so I could understand each person's relationship with the idea of "witch" and uncover resonant threads in their practice of witchcraft. The majority of my subjects also chose to contribute written responses to a set of questions I later sent them, edited excerpts of which accompany their portraits in this book.

As hard as I've worked to be comprehensive in this visual catalog, it is by no means definitive. There will undoubtedly be those who feel unconsidered. I acknowledge the many male self-described witches who have reached out to me. The scope of my work as an artist has long focused on what it means to inhabit the guise of "woman," and I set my framework for this series accordingly. That said, I made efforts to represent much of the gender spectrum, including genderqueer, nonbinary, and trans individuals.

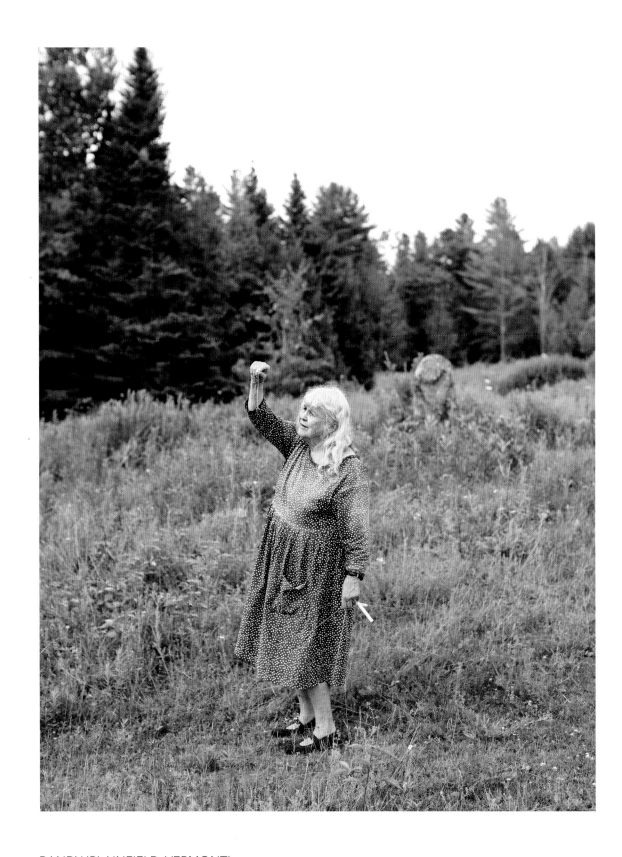

RANDY (PLAINFIELD, VERMONT)

The very power of the word [**witch**] lies in its imprecision. It is not merely a word, but an archetype, a cluster of powerful images.

Margot Adler, *Drawing Down the Moon*

I identify as a Neo-Pagan witch.

The word "witch" means everything to me. It's who I am as a woman: divine, connected, intuitive, magical, sexual, powerful, commanding. A witch is a woman who lives in tune with the cycles of the earth, the cosmos, and herself. It's a woman who lives powerfully, consciously, and unapologetically. A witch is someone who works with magic, who knows how to heal and hex, who knows the power of the self. The word "witch" is my soul, my filter, my lens. It's how I live. It's my purpose and my passion and one of my biggest powers. It's both an adjective and a noun.

My practice works by the phases of the moon as well as the wheel of the year. I work with meditation and breathwork, candle magick, sigils, glamour magick, sex magick, planetary magick, tarot, crystals, mantras, energy work, and herbal magick. I have been working with Venus as my matron goddess for two years and also work intimately with Hecate, Lilith, and Kali. My practice is mostly solitary, though I do work with groups for ritual work and am studying Hermetic Qabalah as a student.

—Gabriela Herstik

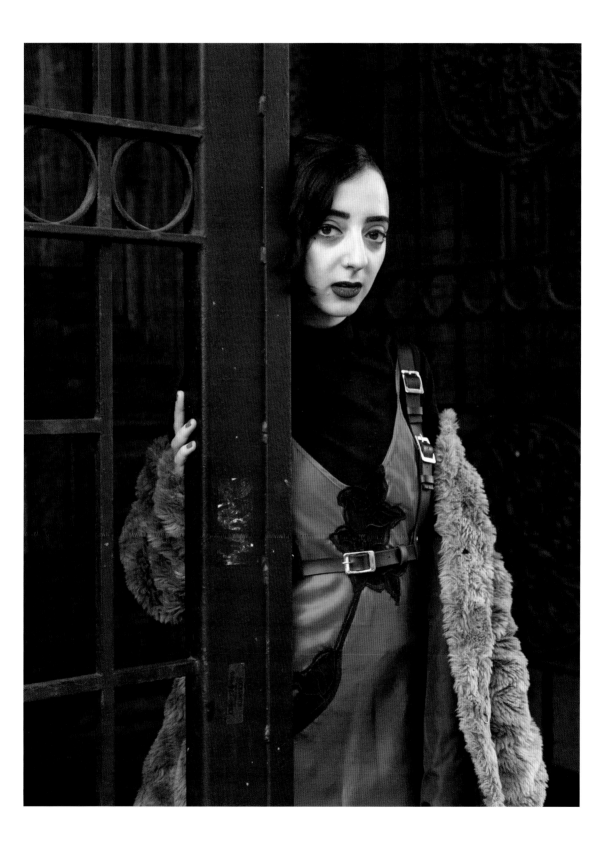

GABRIELA (NEW YORK, NEW YORK)

Frankly, I think that if your witchcraft is not political, you are still asleep. We need to wake up from the idea that witchcraft is just an aesthetic, just a superstition, or just about consolidating magical power for personal gain. In a culture as racist and patriarchal and transphobic and homophobic and materialistic as ours is, if you don't see the way witchcraft is radical and revolutionary, you have some waking up to do.

—Leonore Tija

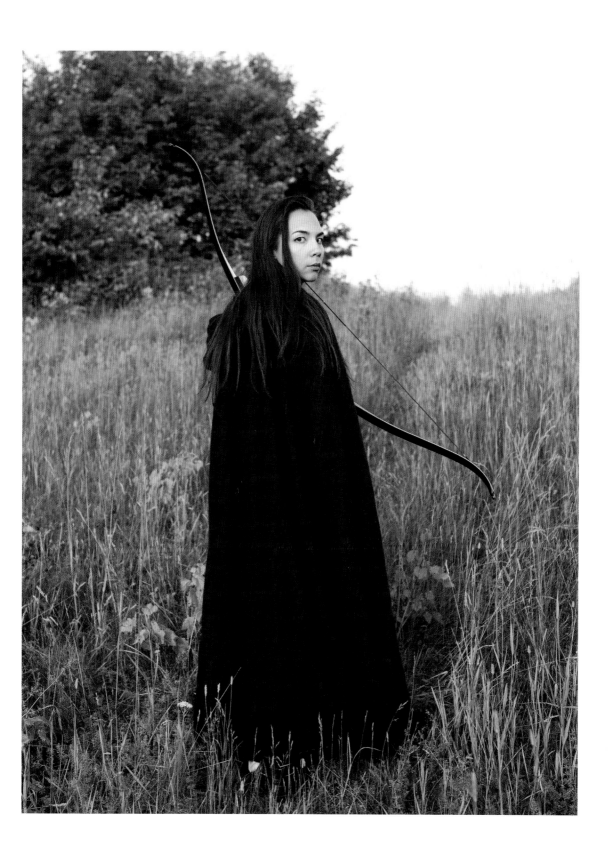

LEONORE (MONTPELIER, VERMONT)

I never considered myself a witch. I consider myself the descendant of healers. The granddaughter of medicine people. My grandfather and my grandmother knew spirit, plants, and how to heal, and they passed this on to me. They never called themselves anything. I realize now that many would call me a witch because of my knowledge of things that are intangible and not always seen. I am cool with it. The witches of Africa are powerful and influence change in great ways. I'm about that.

I work with plants. Plants are energetic beings, just as we are, and their energy matches ours to create healing. Many times they heal more than what we initially thought we were addressing. A plant healer is someone who matches the plant with the person. This can feel like witchery.

Within the community of herbalists and healers, the practices of Indigenous people have been appropriated and capitalized by white people. BIPOC [Black, Indigenous, and people of color] healers and herbalists are often sidelined in popular herbalism culture to the point where our ancestral wisdom is not valued as much as European wisdom, or until it's packaged and taught by someone who is white. For me, this is the way I have felt unsafe in my identity as a Black woman healer. "Unsafe" to me means silencing the voices of marginalized folks. I have seen that so many times in this work.

Black women have always been healers and we should share our stories and wisdom.

—Karen Rose

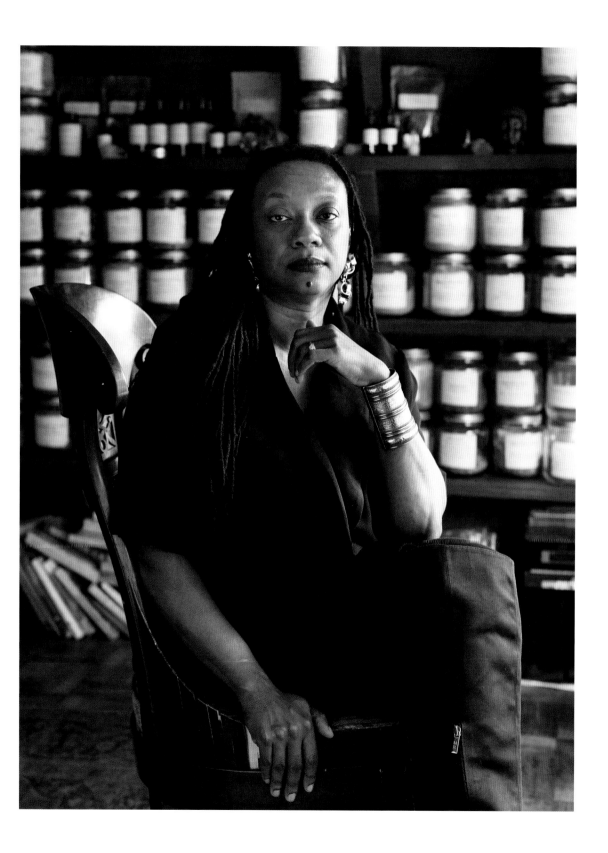

KAREN (BROOKLYN, NEW YORK)

When you call yourself a Witch, people ask you to perform a spell, to curse someone, to get someone to love them, or to turn someone into a frog. This is nonsense, of course. The word "Witch" honors those of our foremothers who were marginalized and trivialized, tormented and tortured, demonized and even burned at the stake.

A Witch is a mover and shaper who draws power from the natural world and from within herself. She attunes her life to the natural cycles of the world and tries to live a life in harmony with them. By natural cycles I mean the annual Solstices and Equinoxes, the monthly lunations of Full, Dark, and New Moon, and the agricultural seasons (in the Northern Hemisphere, in my case). Our natural cycle is birth, initiation, consummation, repose, and death. A Witch sees herself as part of an interconnected and interdependent web of life; she respects all life forms as being necessary and mutually dependent upon one another.

All Wiccans are Witches but not all Witches are Wiccan. "Wiccan" is specifically British-derived and lineage-based. "Witch" is a broader, more inclusive term. That said, times have changed and terminology has loosened, so today there are many who are not British-derived, and who may or may not claim a lineage, who call themselves Wiccan. My preferred adjective is Witchen.

—M. Macha NightMare

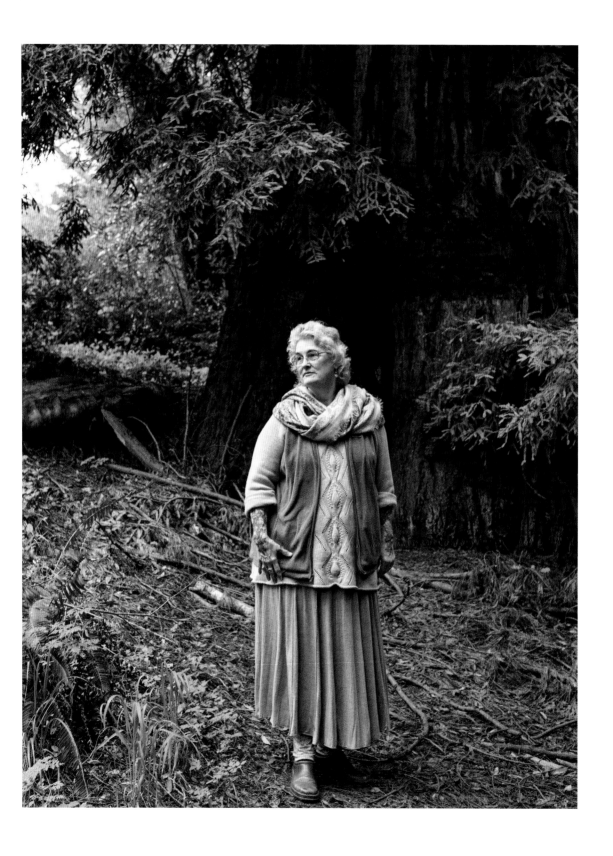

M. NIGHTMARE (SAN GERONIMO, CALIFORNIA)

I'm a freaky splosh poet frog man turmeric slime wild rose indigo hoe bath magic shadow witch.

"Witch" to me means a person/entity who engages with the seemingly unseen forces at work in our existences. A witch is a healer. A witch is a channel. A witch is unafraid to tap into the mystery, the unknown. A witch is a seeker seeking.

What I believe needs to occur within the community is we as individuals need to decolonize our beliefs, minds, medicine, and the spaces in which we gather. To be open to discussion and questioning of culturally appropriative practices in order to end that practice. To listen to the voices and experiences of trans, queer, nonbinary, Black, Indigenous, and people of color. Doing this in a way that isn't extracting free, exhausting, and painful labor from these groups of people from whom we can learn. Letting go of practices that we may have attached ourselves to that felt good but then we learned are problematic (burning white sage/palo santo, using words/language that are appropriative) and understanding that entitled mind-set. Be accountable for some of the ways we may be benefitting from colonial privileges and worldviews. Educating ourselves and others through an intersectional lens. Examining our behaviors and how we can heal ourselves to better heal others and our communities. We have a lot of work to do to smash the system and we can only do it together.

—Alex Patrick Dyck

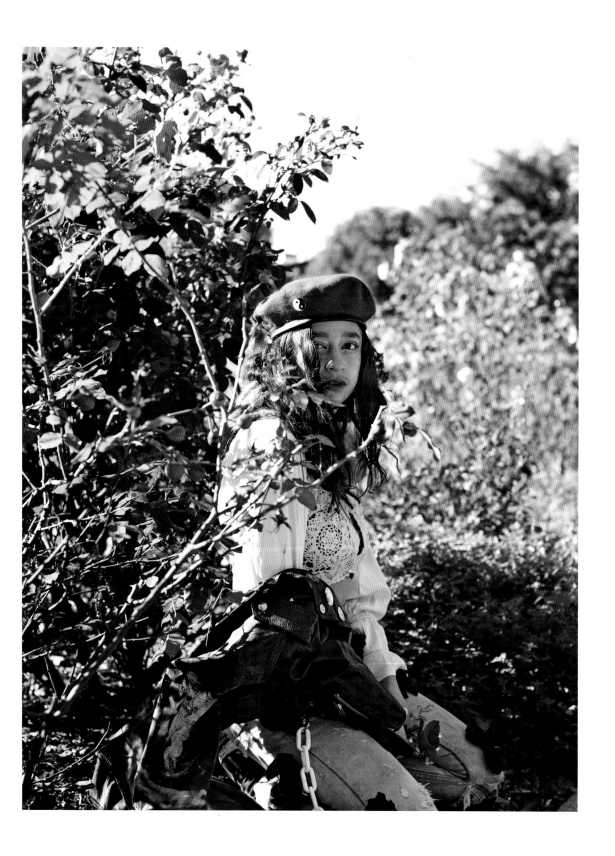

ALEX (BROOKLYN, NEW YORK)

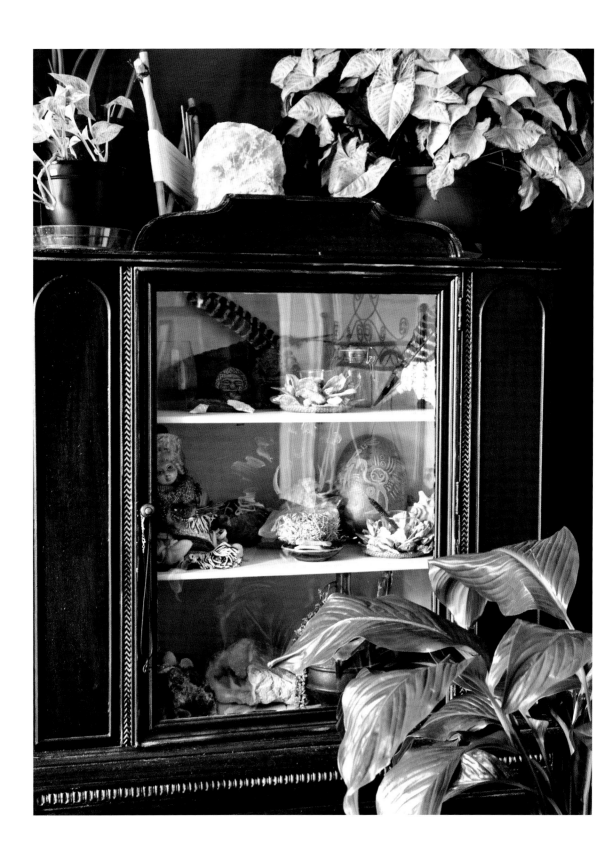

CURIOS (JERSEY CITY, NEW JERSEY)

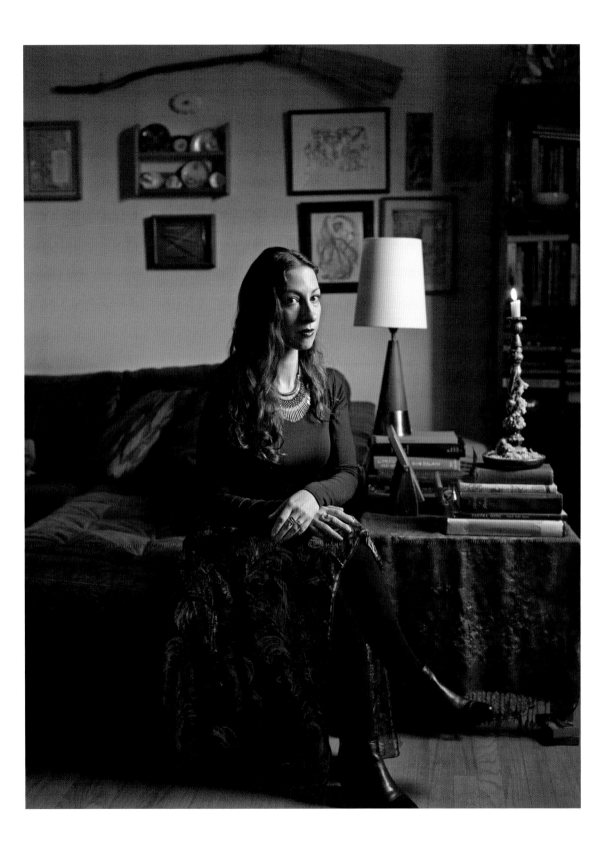

PAM (BROOKLYN, NEW YORK)

As a child in school, I was mocked for my interests in the occult and witchcraft. I learned to become very secretive. Years later, while in an abusive marriage, whenever I gave the slightest indication of leave-taking or standing up for myself, my then-husband would threaten to tell the court I was a witch, telling me that because of this I would lose custody of our children. I took his threats seriously.

Those experiences are specific to me, but there's also always the greater threat: for much of history, it's been dangerous to be identified as a witch, whether or not you actually are one, and that's still true in some parts of the world. I used to be a very intrepid traveler, but now there are places I wouldn't go for fear of anti-witchcraft laws. Witches are currently comparatively safe in the West but that could always change.

—Judika Iles

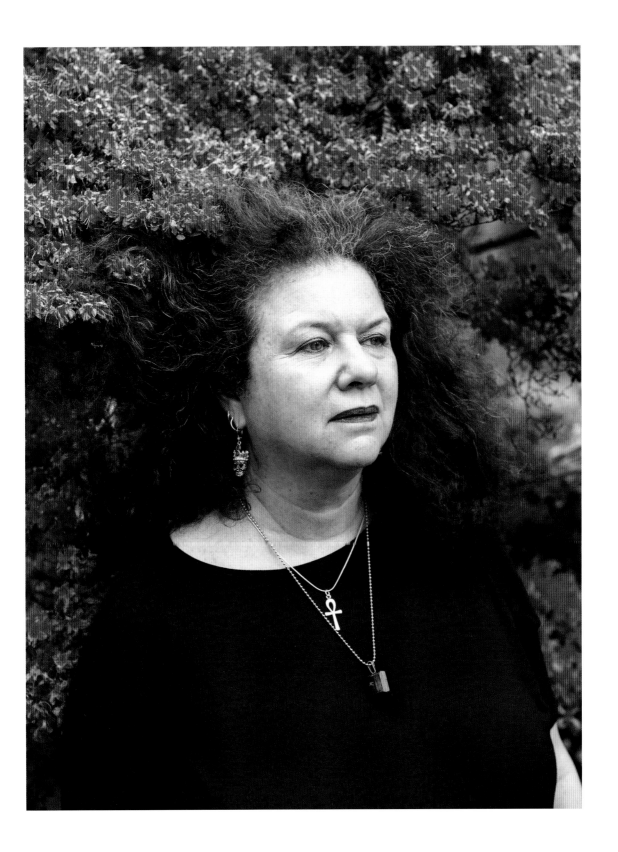

JUDIKA (BROOKLYN, NEW YORK)

I've always understood "witch" to stand for someone who is in tune, both with themselves and the world around them. Personally, I've always been a highly empathic person. While this can manifest in a really anxious way (being stressed by tension, and others' moods and pain), it also gives me a unique way to connect with others, specifically when reading tarot. I think a "witch" is largely someone who can harness their intuition and consider it a gift.

—Kir

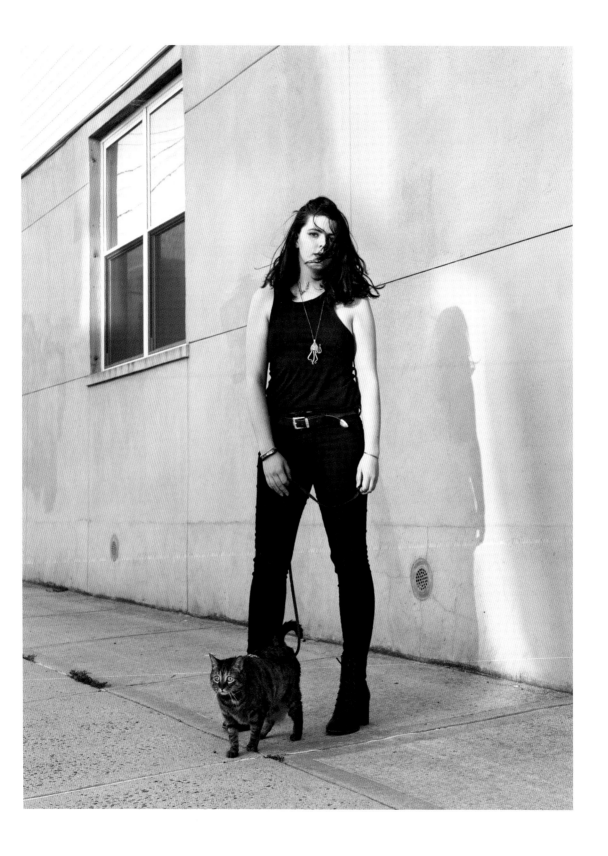

KIR (BROOKLYN, NEW YORK)

GLASS STONES (MORETOWN, VERMONT)

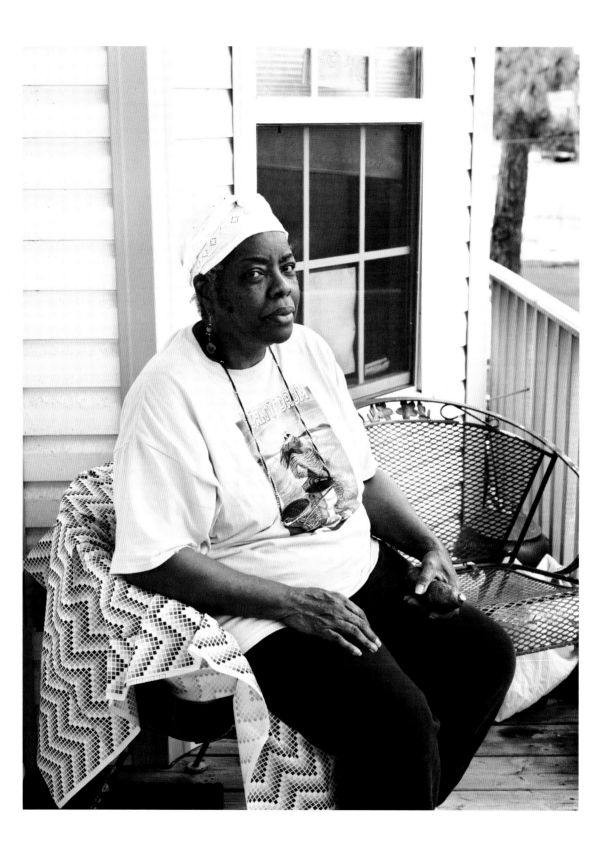

LUISAH (NEW ORLEANS, LOUISIANA)

I teach and priestess in the worldwide feminist, non-hierarchic Reclaiming Tradition of Witchcraft. My tradition is an activist tradition—taking action for the world we want to live in is a core principle among us. I act for justice of all types—this, too, is spiritual and political—and my actions run the gamut: teaching in mundane and magical communities; writing fiction, letters to editors, and nonfiction articles; nonviolent direct action; convening allies; lobbying policymakers.

Witches consciously work with energy to create change. That's magic. Witchcraft is an Earth-based practice: we Witches create change here in our realm, aligned and in partnership with nature, with Earth. Witches are able to hold both sides of paradox and ambiguity at the same time, and it is our ability to work with the energy between that yields dynamic magic. From dichotomies, we often navigate a third road, ripe with power and potential. For instance, the Goddess is transcendent and immanent; I know the Goddess and She is unknowable; the Divine is gendered and ungendered, is within me and without. Witch is a verb, more about action and moving, about dynamic relationships with this world, all beings, all the worlds.

—BrightFlame

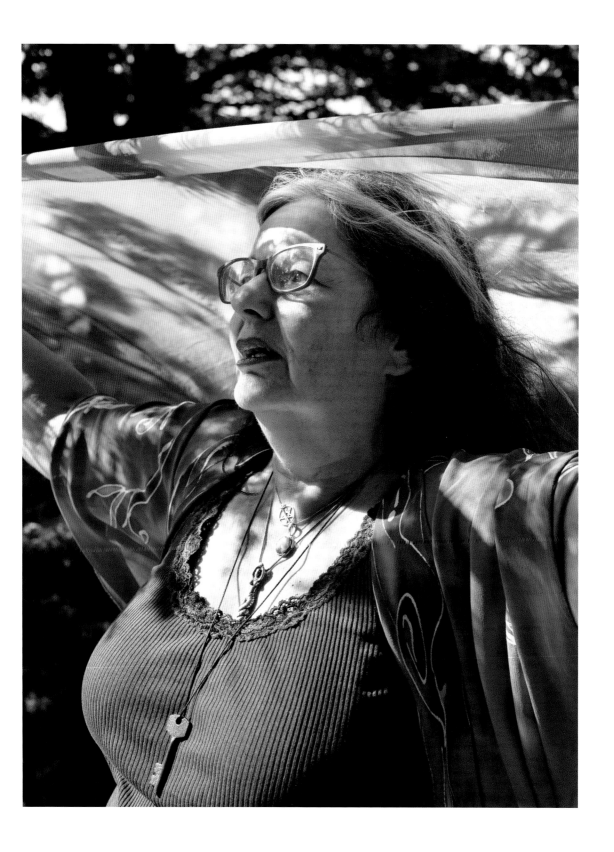

BRIGHTFLAME (NEW YORK, NEW YORK)

As a professional dominatrix, I find that the principles of BDSM and magic run parallel. There is the notion of creating a container—a safe space and/or a circle—to do "the work." In BDSM, this container is created with boundaries regarding consent and limits. In witchcraft, this container is created by calling in the directions and having a magical intent. What happens within this container is often the intention being played out by the expression of the unconscious— symbols, deities, dance, meditation, sensations, role-play, pain, and pleasure. Submerging into liminal spaces can facilitate trance and meditative states. After the work or the play concludes, the circle is closed by releasing the corners in witchcraft and with aftercare in BDSM.

—Dia Dynasty

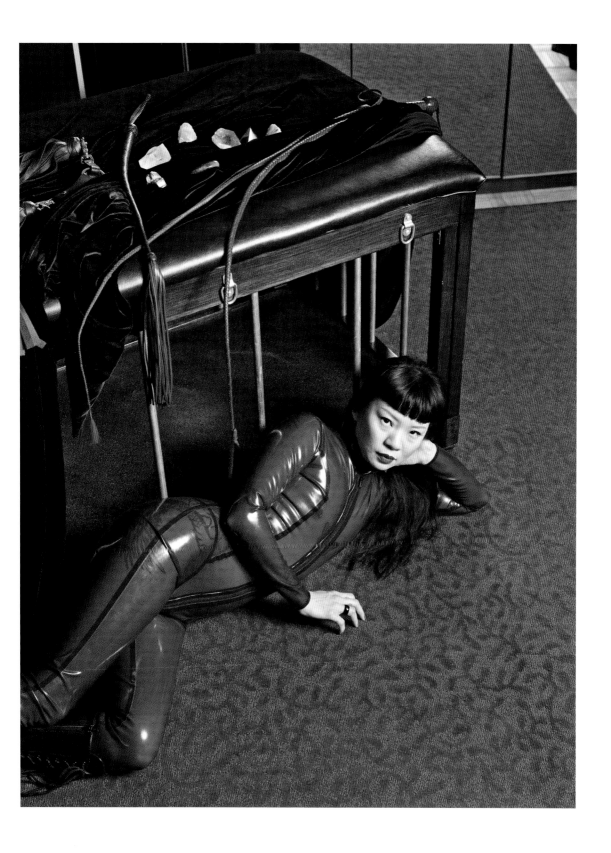

DIA (NEW YORK, NEW YORK)

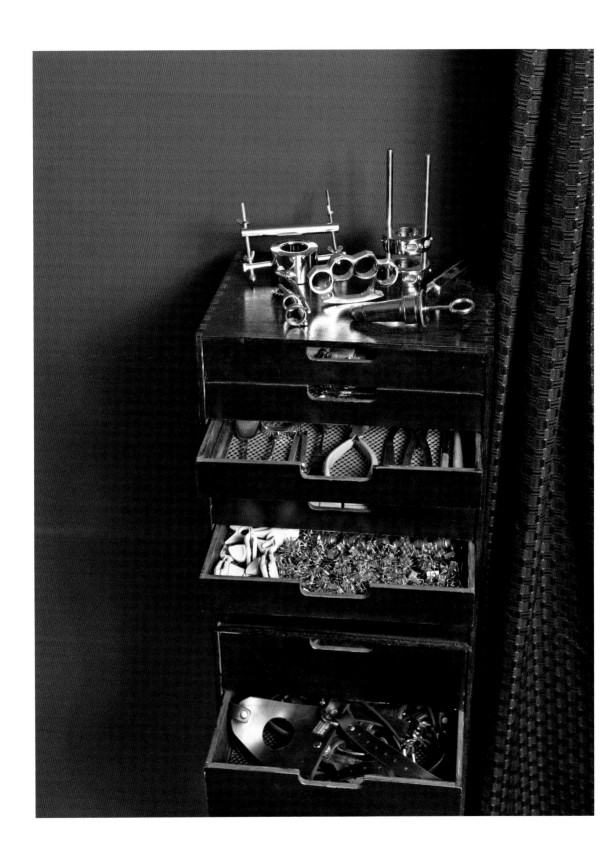

DUNGEON TOYS (NEW YORK, NEW YORK)

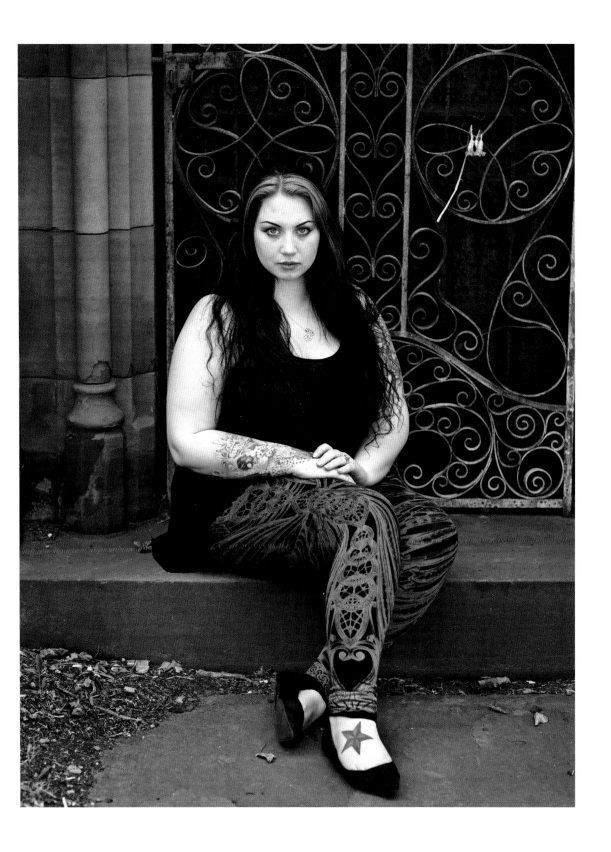

LEXI (NEW YORK, NEW YORK)

I have two full-time jobs. I am the High Priestess of a 501(c)(3) Wiccan Church, which takes up most of my weekends and evenings. My paying job is as a surgical coordinator for the local organ procurement agency. For the past seventeen years, I have helped facilitate the surgical recovery of human organs for transplant.

I feel that although my patients are brain-dead, and have started to cross over the veil between our physical world and the spirit world, they are very much still here, and I speak to them (silently) to thank them for the immense gift of life they are giving.

I believe in reincarnation and that our spirit is made of energy that does not die; it just transforms. I feel and treat my donors with great respect and love until they (the body) are out of my care. But I know their spirit hears me.

—Debra Jeffreys

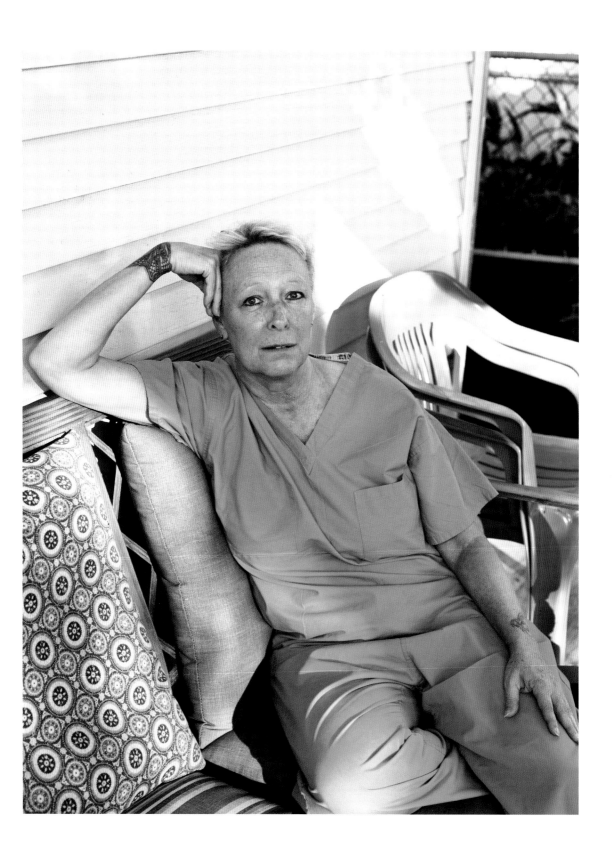

DEBBIE (METAIRIE, LOUISIANA)

I've been in the Craft all my life—in various formulations of it. I've always felt different. Though I am a part of various underground scenes, tribes, and private gatherings, I am a floater and walk alone. I welcome knowledge, teachers, and conversation, but I remain in a gray area.

I believe there are secrets that are never meant to be shared outside a race, class, coven, or entity group. Everything is not for everyone. Knowing your own shit is the key. Wield it.

—Djinn Wolf

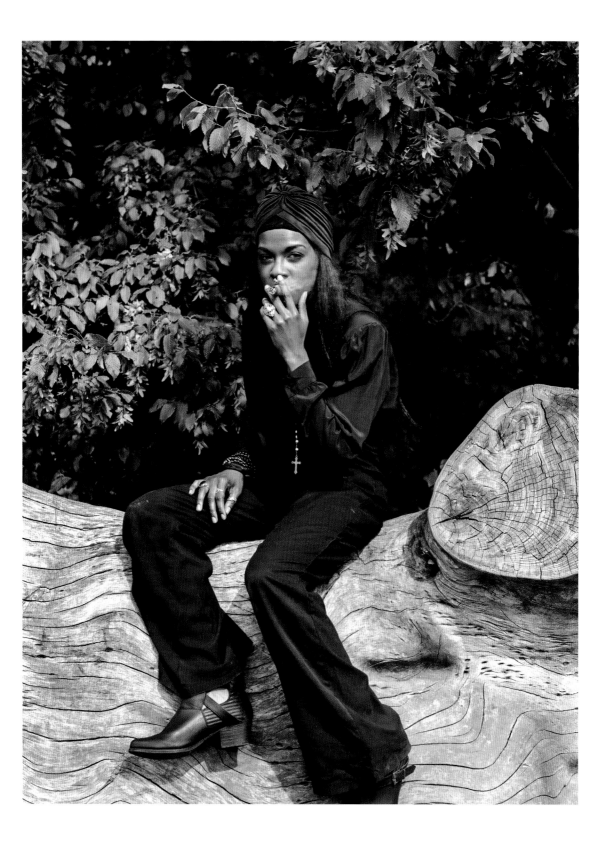

WOLF (BROOKLYN, NEW YORK)

As a witch, I am always ready to address situations that arise in my life through a vocabulary of spontaneous ritual energy magick. For example, the afternoon I knew my sister Dabney was dying thousands of miles away, I was heartbroken that I couldn't be with her. Instead, I followed my intuition and made a ritual of my own.

I honored Dabney's death by doing two things she would have enjoyed: I took a bath with a CBD bath bomb and painted my toenails. Then I kept the box and bag the little bath bomb had come in. A few hours later, as the Goddess would have it, I needed to be at a women's sacred circle. When it was my turn to speak, I told everyone what was happening and passed the little package around, asking these powerful women to fill it with their energy in her honor.

When the box had traveled around the circle, I could feel everyone's energy vibrating in it. I held the powerful box and chanted to my sister's spirit, which was just then leaving the earth. Then all of us chanted, to burn away her loneliness, to burn away the patriarchy that had kept her from other women, to burn away the silence that had been forced on her. We chanted to help her spirit burn, a bright flame always, lighting other women's way to power. We chanted for her freedom, and our own.

The chant went round and round the circle, rising, rising. The women's voices urged her on and on. I could feel the fiery core of her spirit starting to burn free. The circle felt like it was about to take off into outer space from the cathartic energy of all these women's voices, chanting their rage and frustration, and their hope. I led the chant to a final crescendo—and then, the exact instant we stopped, the electricity went out on the block, all the lights in the room cut out at once, and we were left, laughing, awed, and grateful for mystery, in the light of a dozen candles' dancing, glowing flames.

—Annie Finch

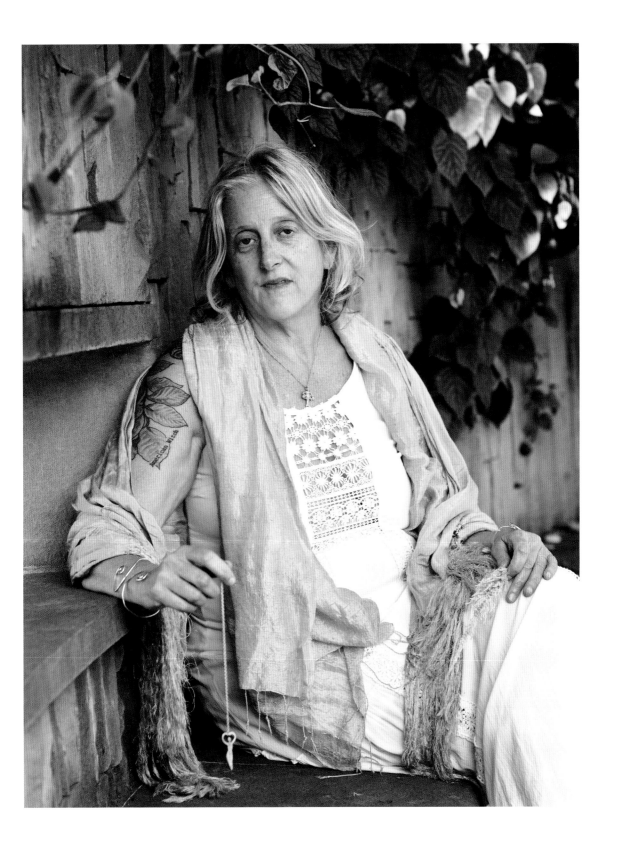

ANNIE (BROOKLYN, NEW YORK)

My upbringing was pretty rough. I was born and raised in Providence, Rhode Island. I don't talk about it too much because it's taken a long time to remove myself from a lot of the pain associated with it. As a kid I would explore the nearby Catholic church for peace and quiet. I would also visit friends from school and the neighborhood whose families were from other religious denominations in search of connection to the spiritual and something that could provide inner peace. Through this exploration, I found books on the occult online, in magic shops, and through my mother's friends. Finding witchcraft, spell work, astrology, tarot, and other means of magic provided a welcome escape from the personal hell I was in. It helped call my power back and changed the course of my life.

I read tarot and oracle for a living, perform public ritual, teach metaphysical classes, and create magical tools, oracle decks, zines, and books. I consider myself a Spiritualist. Someone who engages in magic and the natural world but without a religious pretext. I do not identify as Pagan, Christian, or Wiccan. I am omnipresent to all things, so Spiritualist feels like a good way to encapsulate all that I do as an artist, magician, witch, ritualist, and psychic reader.

—Marcella Kroll

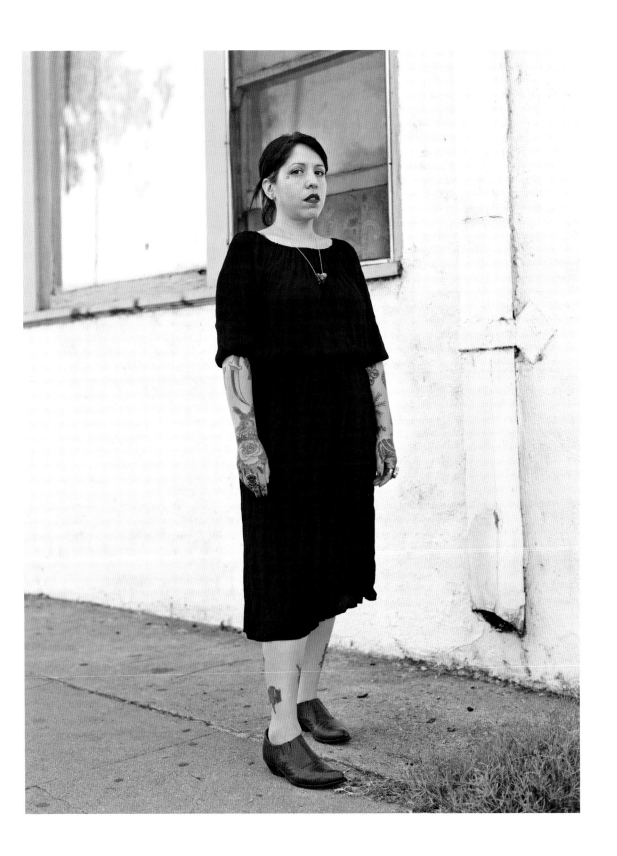

MARCELLA (LOS ANGELES, CALIFORNIA)

CANDLE DRIPPINGS (WATSONVILLE, CALIFORNIA)

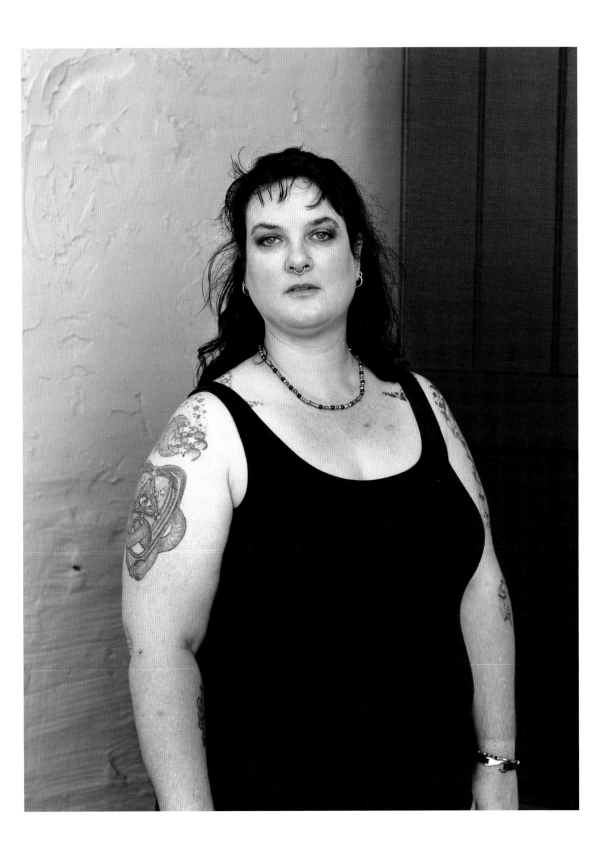

ANDE (NEW ORLEANS, LOUISIANA)

I have a difficult time pinpointing when I first became interested in witchcraft. It was during childhood, for sure, coming with a slow and painful realization that my mother's religion was one of shame, fire, and brimstone. Her vengeful god did not sit well with me, even as a babe, and I was hiding oracle cards and *The Spiral Dance* by Starhawk under my bed before I was a teenager. Even so, fear kept me from claiming the name "Witch" for myself until I was twenty-five years old, nursing my newborn son in the middle of the night and deciding I no longer wanted to hide a huge piece of who I was, because I never wanted this baby to hide who he was, and my childhood church had sourced in me an incredible distaste for hypocrisy, you see.

Balancing Witchcraft with motherhood has always been interesting. I have two boys, now ten and thirteen, and I've been very open about my Craft for their entire lives. I decided early on that I was not going to indoctrinate them into my spiritual practice the way I was indoctrinated into my mother's religion as a child, so they're around it all the time—immersed in it, even—but they have this total lack of curiosity, or maybe apathy, about what it is that I do. I teach out of my home (as in, once a month, there are between nine and thirteen women in their house, chanting and dancing, cackling in the kitchen for nine days straight), so this is not something that's hidden from them in any way, and, for me, my Witchcraft is sort of the glue in the family dynamic. When they were younger, they participated. Now, it is only on a select few sabbats that I ask them to circle with me, but I'm hoping they at least see Witchcraft as a practice of beauty, of nature communion, and poetry.

—Danielle Dulsky

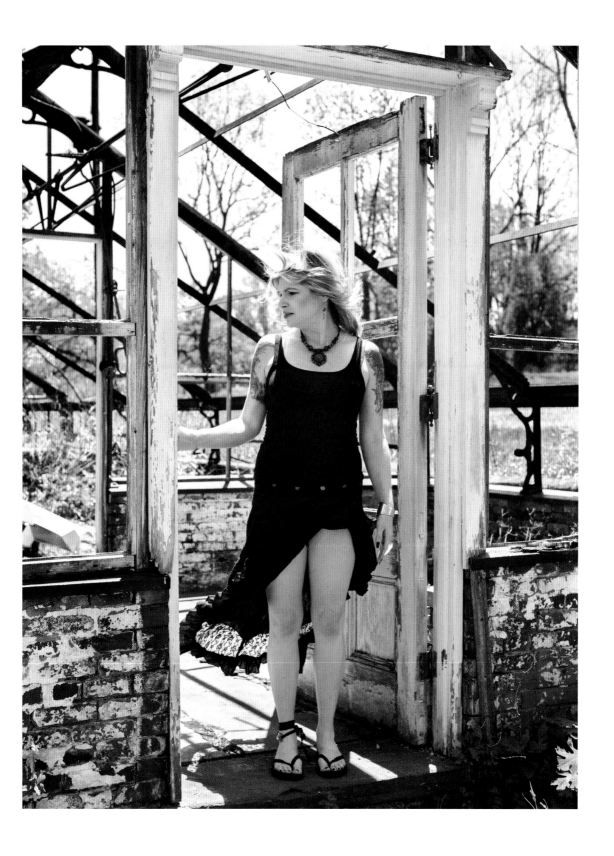

DANIELLE (PHOENIXVILLE, PENNSYLVANIA)

I first became interested in witchcraft when I was growing up in a rural part of Michigan. My grandmother was big into both gardening and storytelling, and so much of my life with her was focused on reading stories of magic, witches, tarot, gardening, the earth, and fairies.

When I was a child, my sister and I would commune with nature and leave certain items out under the full moon to charge or be blessed by the nighttime. I probably wouldn't have called myself a witch then. I think that word came much, much later.

I am a poet by art and trade, and so I have found that my magic comes best through my words and that poems can act as sorts of spells. I am a word witch. Having something to say and having a voice is sometimes the toughest magic there is. It has been such a galvanizing force in my life.

—Kate Belew

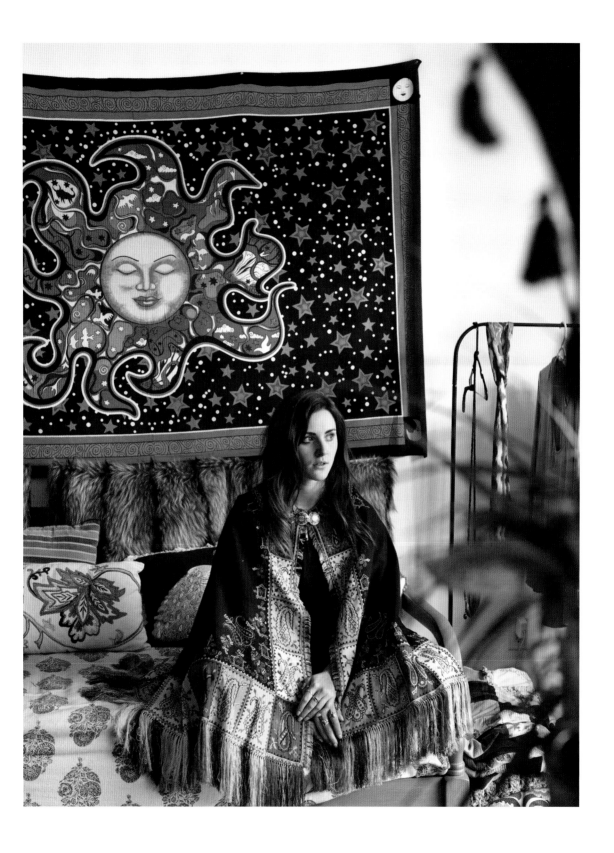

KATE (BROOKLYN, NEW YORK)

EARTHLANDS (PETERSHAM, MASSACHUSETTS)

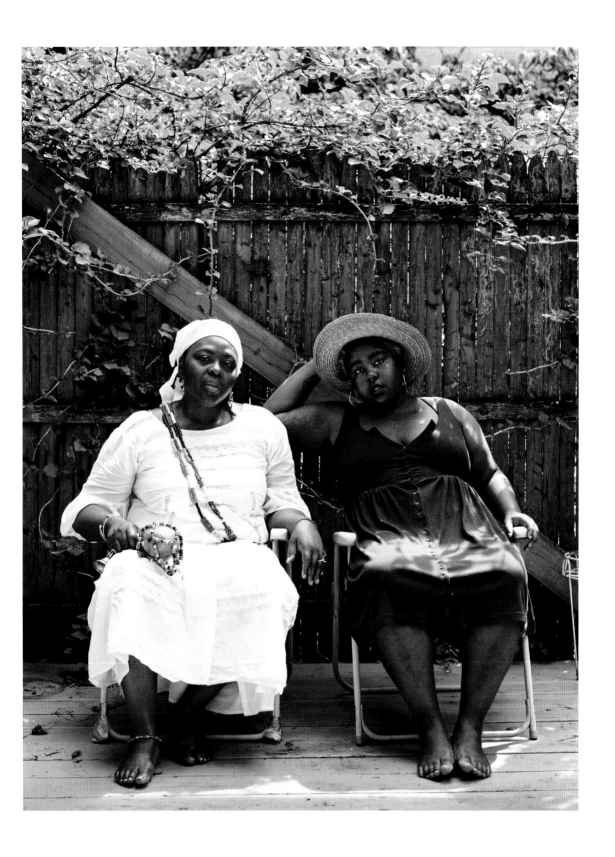

MARIE AND ÉBUN (NEW YORK, NEW YORK)

I belong to a pagan community, Triple Spiral of Dún na Sidhe, where we do full and new moon rituals and follow the Celtic traditions of Samhain, Imbolc, and the Brigid flame. It is a daily practice of connecting with the Goddess through prayer, meditation, and ritual. I am also a Priestess (Mambo) in the Vodou tradition of Haiti. I get more disparaging remarks about that than being self-identified as a witch.

A "witch" is any woman who is grounded in her power, able to manipulate/shift energy for her highest good whether in the boardroom, the bedroom, or the kitchen. Any woman who uses the knowledge of the forces of nature to heal, or consciously manifest, is a witch.

My daughter and I are women of color and voluptuous women active in our communities as healers. My daughter grew up in circles of women who practice all sorts of Indigenous spirituality. Within these spiritual traditions are also what one may call witches, so it is not unique to just the pagans. But it is in that tradition we connect most with the Divine Feminine.

—Mambo Yasezi, Marie C. Nazon, PhD, LMSW

I was really into taking online quizzes in middle school. I remember taking a quiz about what kind of hippie I was and the result I received was "neo-pagan." I was thrilled with that answer because I felt like I was special, that the kind of hippie that I was had more spiritual connections to the earth and the universe. It felt revelatory to me. "I am Neo-Pagan. Hear me roar!" Little did I realize that my whole existence was filled to the brim with witchy rituals and practices—I just never put the word to those experiences. Growing up, witches were always depicted as white women. Therefore, how could someone like me, a Black girl, be a witch?

Taking that quiz was pivotal. But the spiritual experiences that my mother specifically provided for me wholly transformed the way that I engaged with myself and my personal power and the rest of the world. I was shown through my mother's spiritual communities that women (all kinds of women—lesbians, trans women, teachers, priestesses, water-pourers, fire-keepers, activists, Indigenous women, Black and Latina women) have the power to make change for themselves and the world. Now whether that was through praying in a sweat lodge, dancing naked around a fire with other women, or calling on the ancestors for a grieving ceremony, I made subconscious notes about the kind of person I wanted to be in this world. The title "witch" will never not be part of who I am and my legacy. It's so powerful.

"Witch" is totally political for me. It is a political practice in that it allows folks to manifest things for themselves and their communities rather than relying on a capitalist system. Solutions are found through community and self-spiritual guidance instead of capitalism and all of the ways it drains people of their power. I think capitalism is afraid of the word "witch" because it implies self-sufficiency. How could capitalism work if everyone was self-sufficient?

—Ébun Zoule (daughter to Marie)

When I was sixteen living in Santa Barbara, California, where I grew up, fate connected me with a powerful healer and medicine woman who became my mentor. I was working as a hostess at a Moroccan restaurant and she was the belly dancer there. One day, within my first few weeks working at the restaurant, she glided up to me after her set and asked if I wanted to work for her at her small healing boutique (read: magic shop) nearby. I had been spiritually hungry for as long as I could remember, and I'd become familiar with meditation by then, but practical magic was completely foreign to me.

In the four years that I worked at the shop, my world was blasted open. Healers, mystics, and seekers of every kind passed through those doors. In our downtime together at the shop, my mentor would teach me how to craft spells and cleanse spaces. Her approach to magic was very matter-of-fact. She practiced it because, in her experience, it worked. She rarely used the word "witchcraft" and she didn't openly identify as a witch, but I later understood that witchcraft is what we were practicing.

It was 2010 when I left the shop to move to New York, and it was around that time that the word "feminism" began to tiptoe its way back into the cultural lexicon, so while I was awakening as a witch, I was also awakening as a feminist and gaining an understanding of how deeply those two archetypes are connected.

—Lyndsey Jo

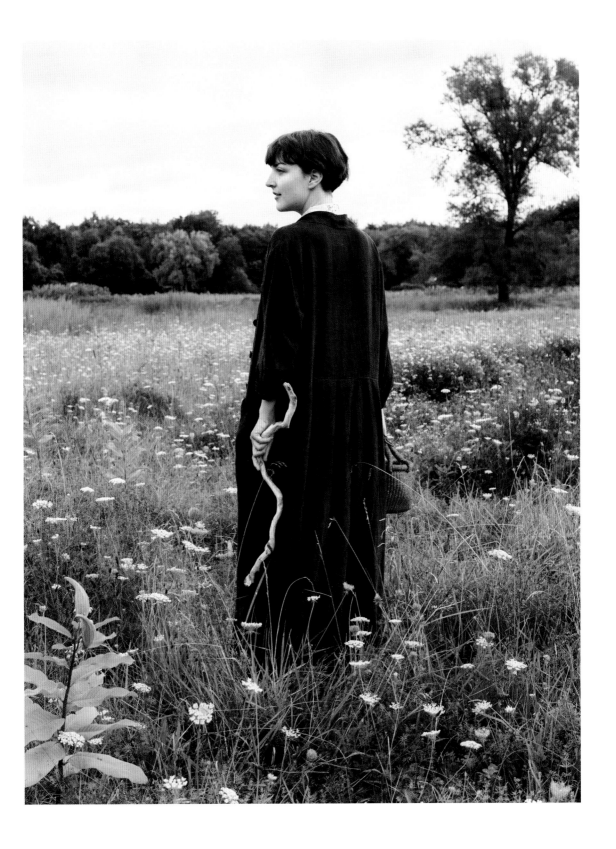

LYNDSEY JO (WOODSTOCK, NEW YORK)

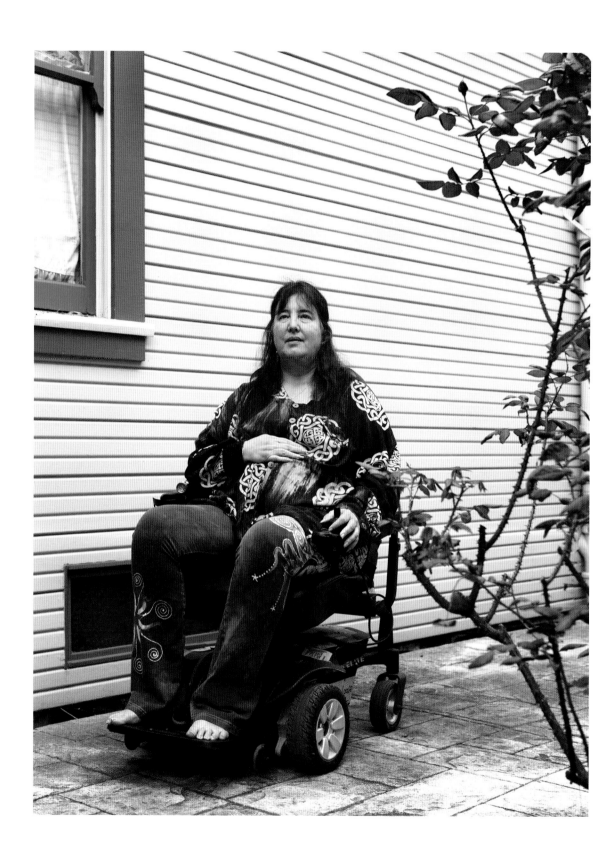

ROWAN (SAN JOSE, CALIFORNIA)

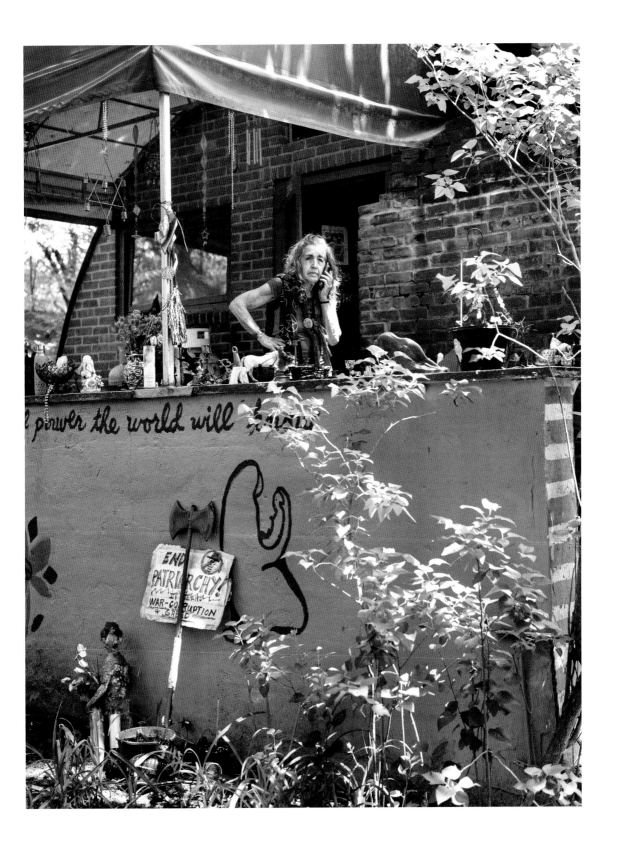

SANDRA (RINGWOOD, NEW JERSEY)

Throughout my life I've been a solo practitioner but have recently found a wonderful community with a few different covens filled with all kinds of witches: kink witches, hedge witches, ceremonial magicians, green witches, Satanic witches, Wiccans, kitchen witches. To me, the witch is a figure who rails against any and all forms of systemic oppression.

My mother is an intuitive and introduced me to the mystical and the manifestational at an early age. Being part of the metal and goth scenes as a kid also provided a gateway into a variety of occult traditions—and aesthetics. I dabbled in spellcraft and did all kinds of sex magic in my teens and early twenties, but it wasn't until a few years later when I was diagnosed with a chronic illness that forced me to quit my job and spend most days in bed that I really began to connect with the identity of "witch" that was pulsing in my bones.

—Kristen Sollée

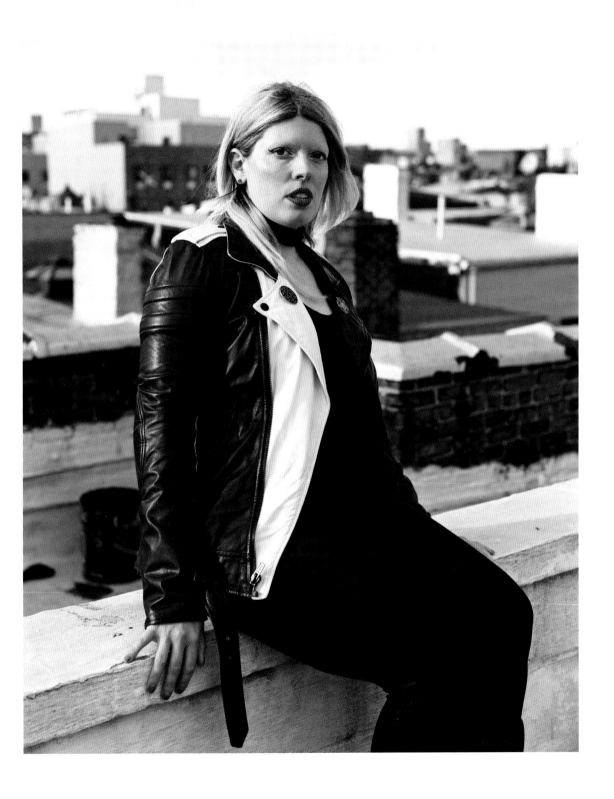

KRISTEN (BROOKLYN, NEW YORK)

My brand of witchcraft is my own: a wild, eclectic brew of hoodoo (Black Native American folk spirituality) and shamanism. I am a solitary witch and the woods are my church. I pray in nature and use the elements to heighten my rituals and ceremonies. I use tools such as drums, rattles, animal bones, feathers, crystals, and sigils, and I channel animal spirits, spirit guides, and ancestors. I pray with my full body and spirit to enter into trance states.

—Shine Blackhawk

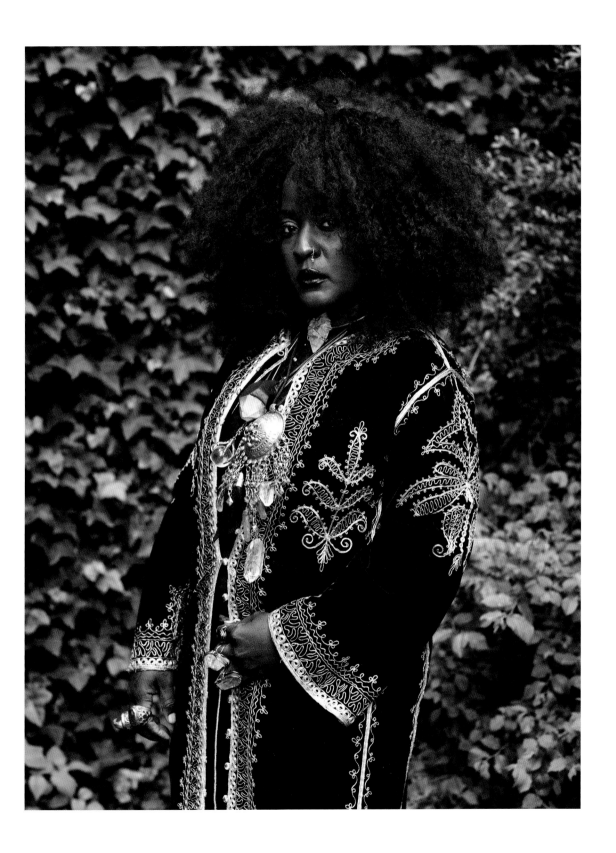

SHINE (NEW YORK, NEW YORK)

I grew up on a multi-generational farm in central Minnesota. I was surrounded by trees, prairie, gardens, and old buildings filled with artifacts from my family's past. I spent a lot of time building intimate relationships with the plants and animals around me and paying attention to the elements in a very experiential way. The smell of the pine trees, feeling the energy change with the weather, or interacting with a deer, rabbit, or tadpole gave me a profound sense of interconnection that has deeply shaped my practice. I created my own ceremonies of intention often involving items such as stones, plants, bones, or items from family members. If I found a hurt animal, I would try to heal it. If I found a dead animal, I'd hold a ceremony to send it on its journey. I'd often sneak out late at night to walk and talk to the trees or the stars and planets. I was often alone as a child and I don't think I ever really thought twice about any of this until I got older and realized that wasn't everyone's reality. School was very difficult for me and I generally felt alienated. I was often focused on the things everyone else seemed to be missing.

My personal witchcraft practice is a lot like my cooking. I don't use recipes—I take what is already present and use it to intentionally create whatever I am needing, working toward, or processing in that moment. I may use my voice, items of significance, my body, my tears, my sex, music; the list goes on. My goals are often different: personal healing, healing for others, exploration, connecting with ancestors or elements. Sometimes I channel different types of energy and there is no conscious goal except to gather information that may be useful or access whatever healing I might need. Sometimes I access something conscious, sometimes primal, sometimes cosmic, sometimes other-dimensional. I often practice in my dream time as well.

—Wilda

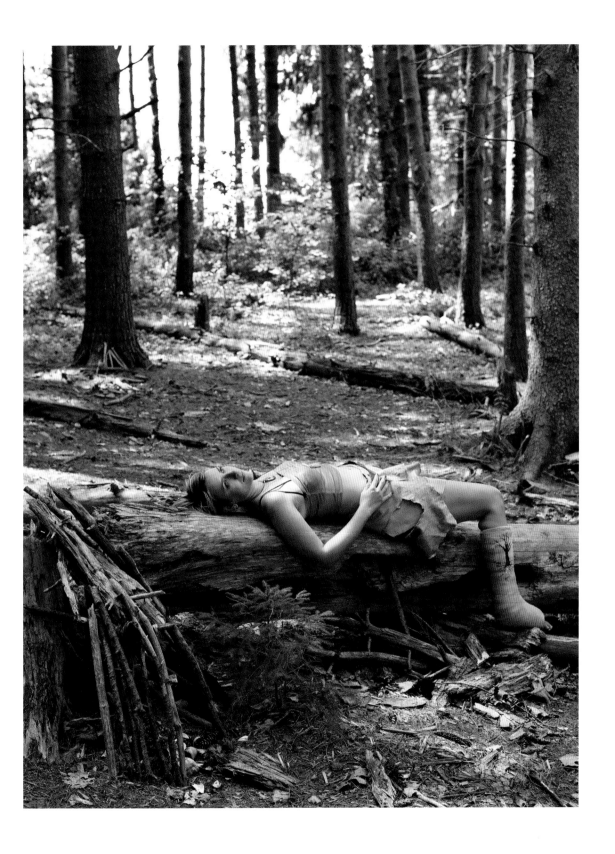

WILDA (MACKWORTH ISLAND, MAINE)

I have a deep connection to Hecate, who is a guide in the underworld, across thresholds. She's the tender of poison medicine and plants, of dogs, the moon, fire, boundaries, and protection. I've found a lot of support and comfort in working with her energy. Beyond that, I don't really connect much to goddess work. The way I often see that show up in others' practices feels pretty transphobic, really centering the "feminine" in a way that prioritizes cisgender women and particular kinds of genitalia and bodies, which I just can't get on board with. I want the kind of magic I'm a part of to be expansive and liberatory, to break down binaries.

I've spent a lot of time exploring my shadows, the trauma and violence I've experienced, through working with poison medicine, breathwork, and also psychedelics, and that work has always been about diving into the underworld in the hopes of witnessing and offering care to what's there. My practice is also about a love for both the shadows and the light, not prioritizing one or the other. Allowing both to be sources of wisdom: understanding they are two poles, two ends, two binaries, and there's a whole bridge of an expanse in between. I'm trying to be the place in between, have it be enough. And actually, I'm not even trying to go anywhere, just be where I am. Become less of a somebody and more of a nobody. I like to think the plants know what I'm talking about.

—Jennifer Patterson

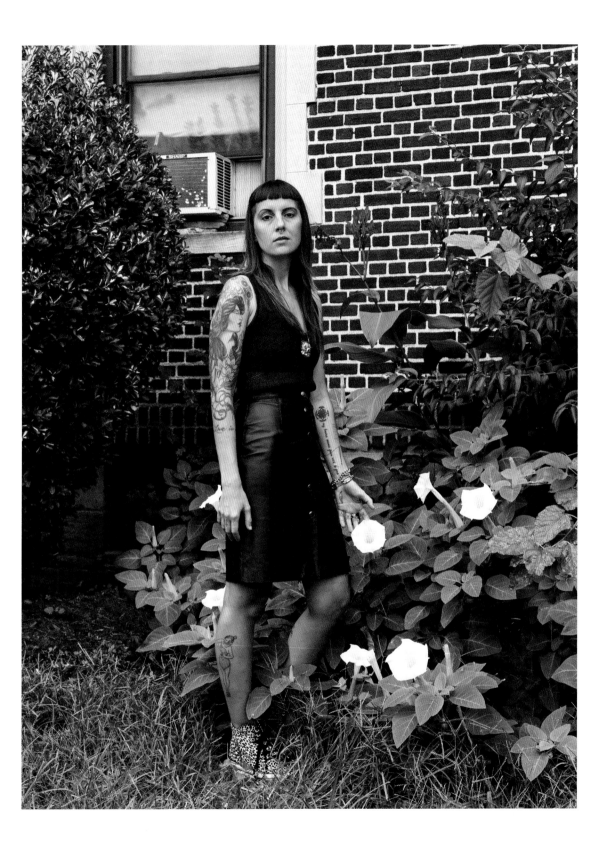

JENNIFER (BROOKLYN, NEW YORK)

When I began practicing in the world as an herbalist, writer, and educator three decades ago, I chose to use the term "Green Witch" because the word "witch" has historically been used to silence women of personal power and influence in their community, as well as poor, uneducated women with little power in the world. It was often aimed as a lethal weapon at healers, midwives, and herbalists in particular. By claiming the word for myself I reasoned that I was disarming those who might think to use it to attempt to silence or oppress me.

—Robin Rose Bennett

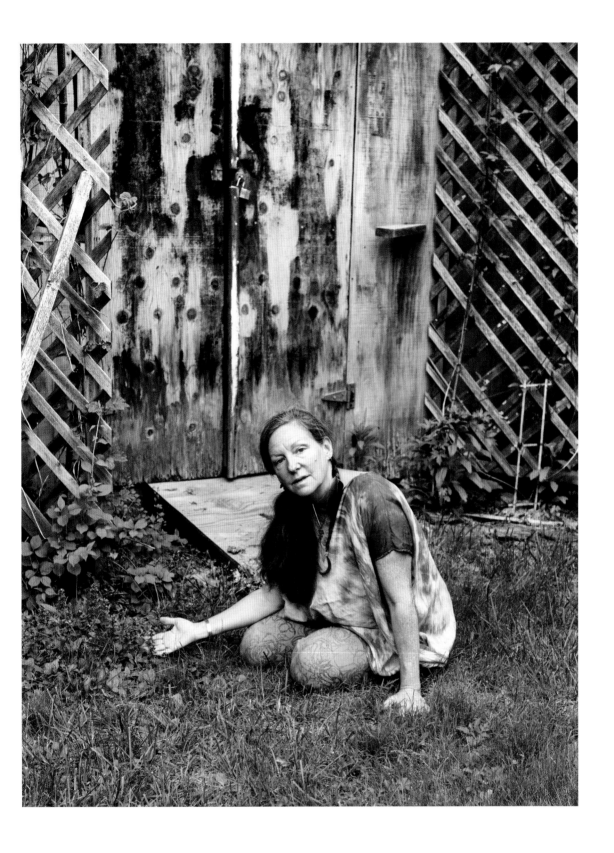

ROBIN ROSE (HEWITT, NEW JERSEY)

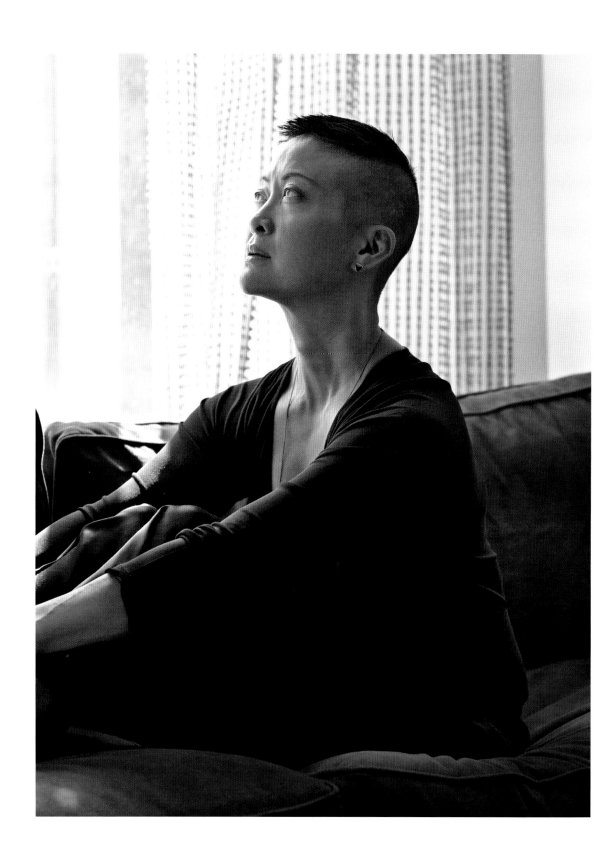

YIN (BROOKLYN, NEW YORK)

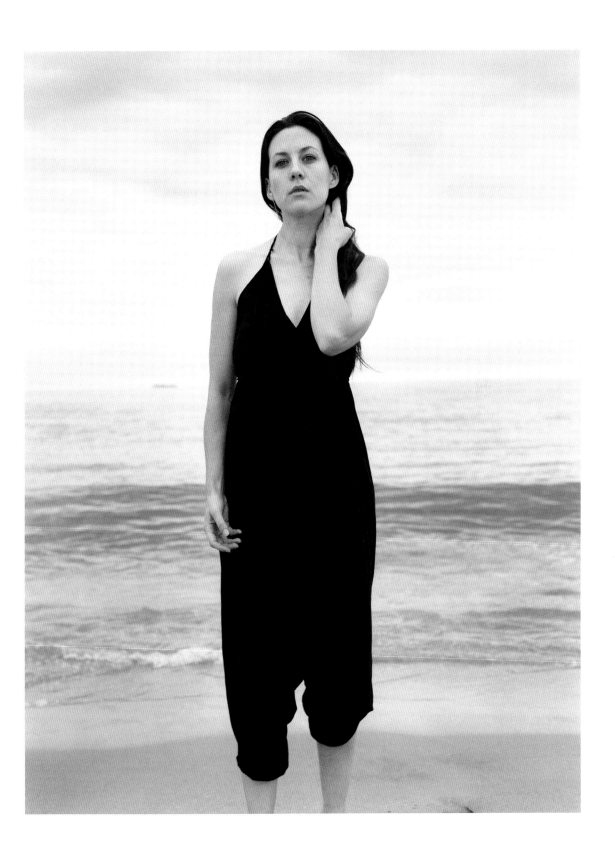

MAUREEN (BROOKLYN, NEW YORK)

When I was young and single, I used to go to bars to practice my love spells. On my walk over, I would leave a candle at a crossroads where someone had spray painted an Erzulie *veve*. I would dress my shoes in oil, wear spell perfumes, wash my clothes in herbal infusions, and fill the soles with love poems. I would secretly slip jasmine flowers and dove feathers into people's pockets and whisper enchantments into their ear. One night I summoned five ex-boyfriends to the bar (two of which were from out of state). It was mostly just for fun, but it was an experimental testing ground where I learned the mechanics of spell work with something that felt safe, innocuous, and delivered immediate, real-world results.

—Melissa Jayne Madara

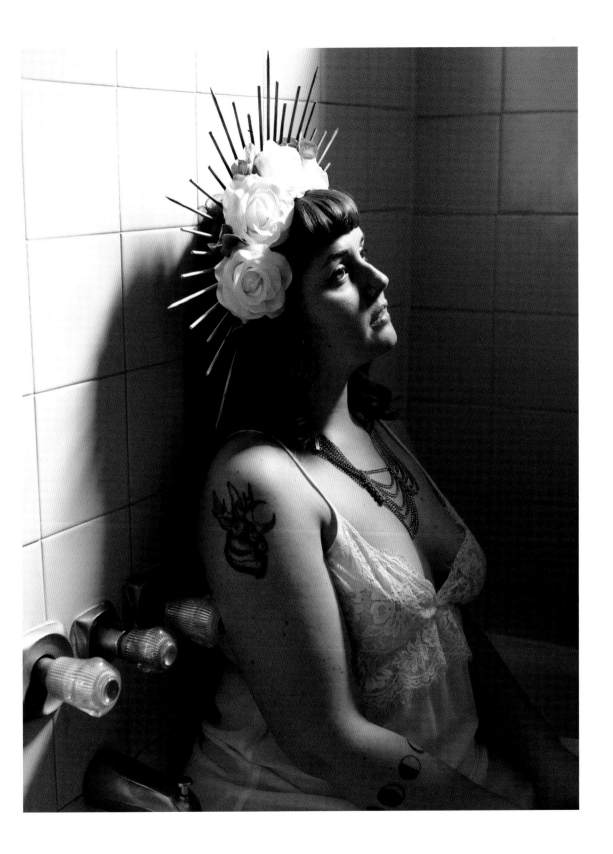

MELISSA (QUEENS, NEW YORK)

I became interested in witchcraft at a very young age, maybe around when I was six or seven years old. I remember the women of my family gathering around my grandmother so that she could read the coffee grinds at the bottoms of their cups. Will I find love? Will I get this job? Will I be happy? The women always stored their used coffee cups until my grandmother was available to read the grinds.

What it means to me now is kind of like being an alchemist of life. To change my course based on intuition or dreams brought to me by my ancestors. I don't have all the answers (though often I wished I did), but there are rituals to perform when I feel empty or sad. Being a witch means never having to face my difficulties alone. When I'm in doubt, I will have dreams about what to do. When I'm happy, feathers will appear in my path to announce the presence of my angels and ancestors. The women of my family, my ancestors, are always watching over me. Always offering me guidance.

—Amy Altagracia Martinez

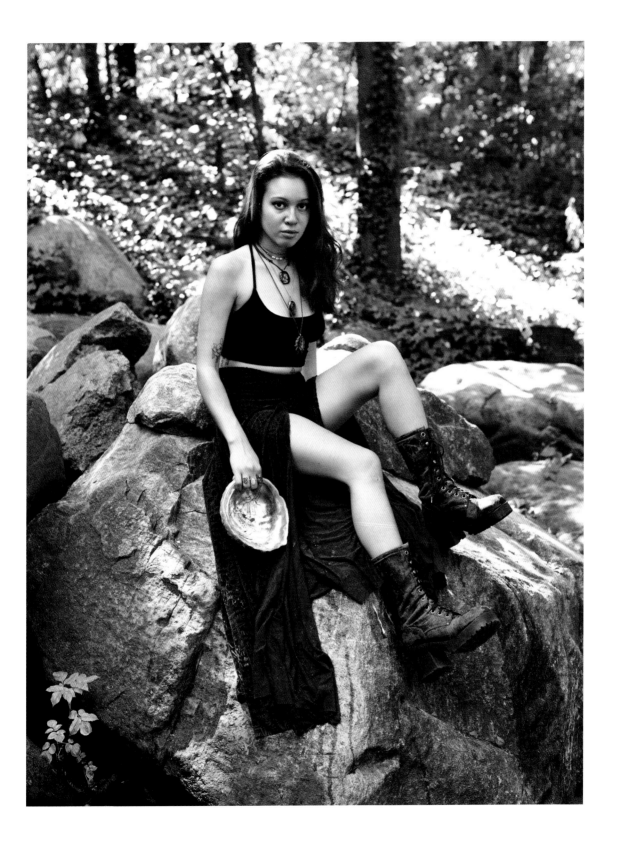

AMY (BROOKLYN, NEW YORK)

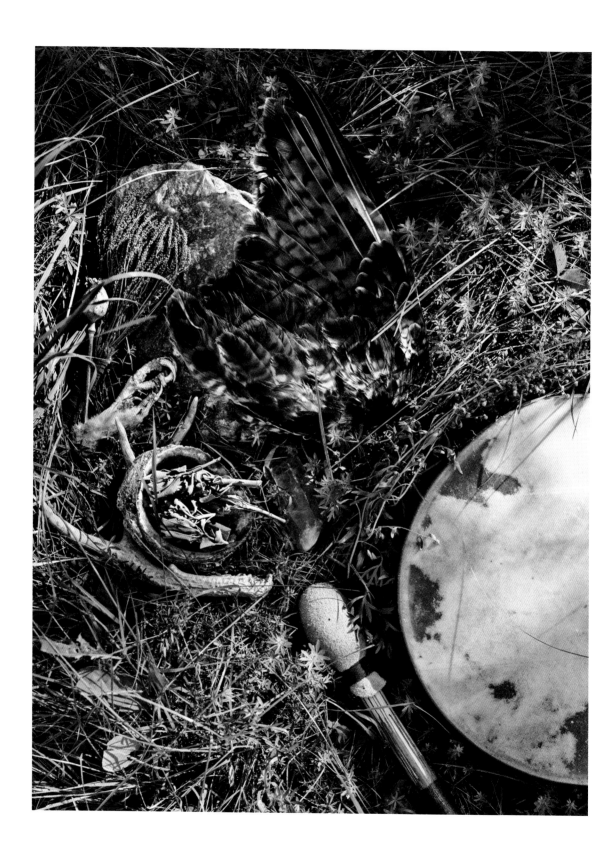

INSTRUMENTS (BRIDGEWATER, CONNECTICUT)

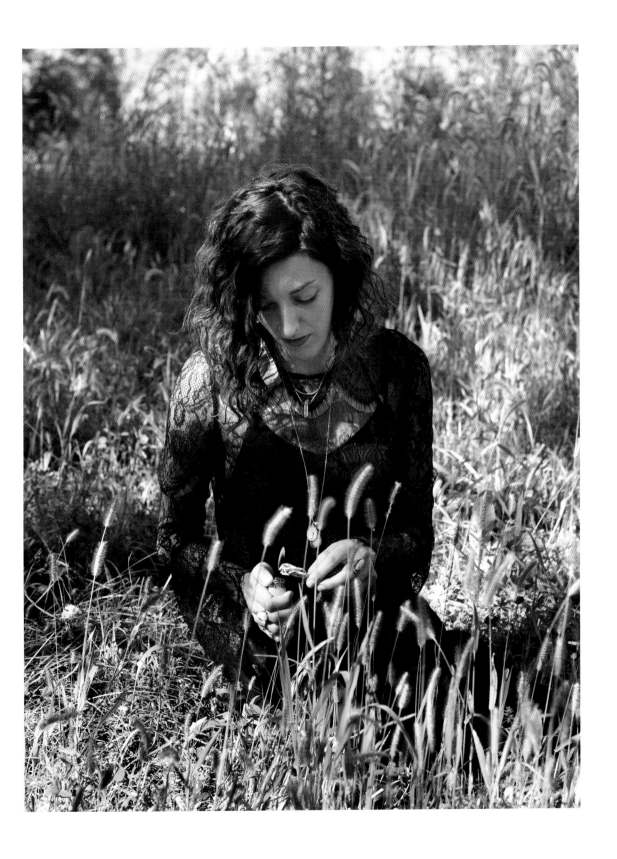

CAITY (BRIDGEWATER, CONNECTICUT)

I think the greater Pagan and witchcraft community (and I use the term "community" with some hesitation, as it is a very fractious community) is going through some serious growing pains. It remains to be seen what will emerge. We have discovered that we have monsters in our midst: sexual predators, white supremacists, and other types of noisome bigots and criminals, and we are, in fact, a lot like other social and cultural groups. We are not so special after all; we are not always better, at least not uniformly so, than those on whom we look down. Some Dianic witches decry the growing numbers of trans women in their midst, claiming that they are men in disguise trying to take over women's spaces, and demand women-born-women-only spaces. Trans persons, persons of color, and other marginalized groups are demanding safety at Pagan conferences and events and demanding the removal of persons whom they consider to be a threat to their individual and collective safety. These types of things have led to further controversies about purity testing, political correctness, social justice warriors, and cultural appropriation.

—Barbara Cormack

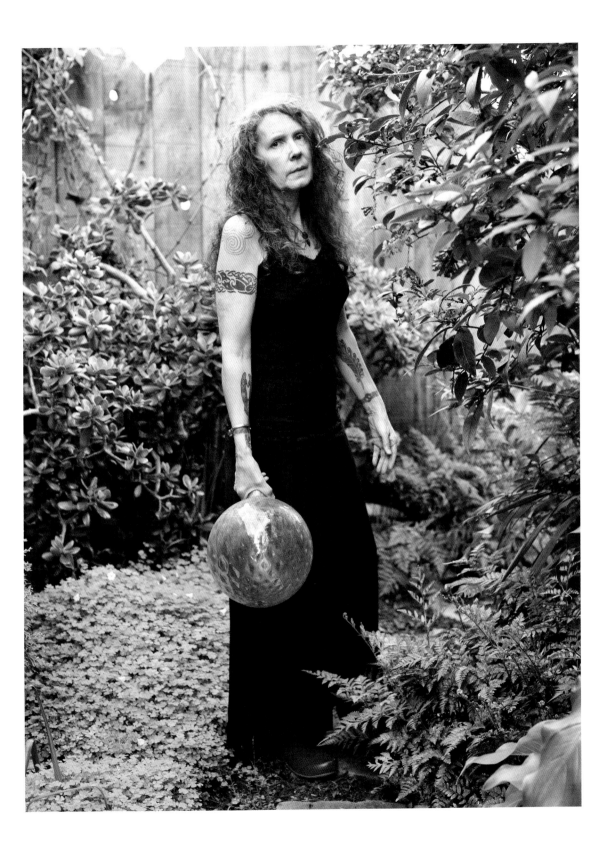

BARBARA (OAKLAND, CALIFORNIA)

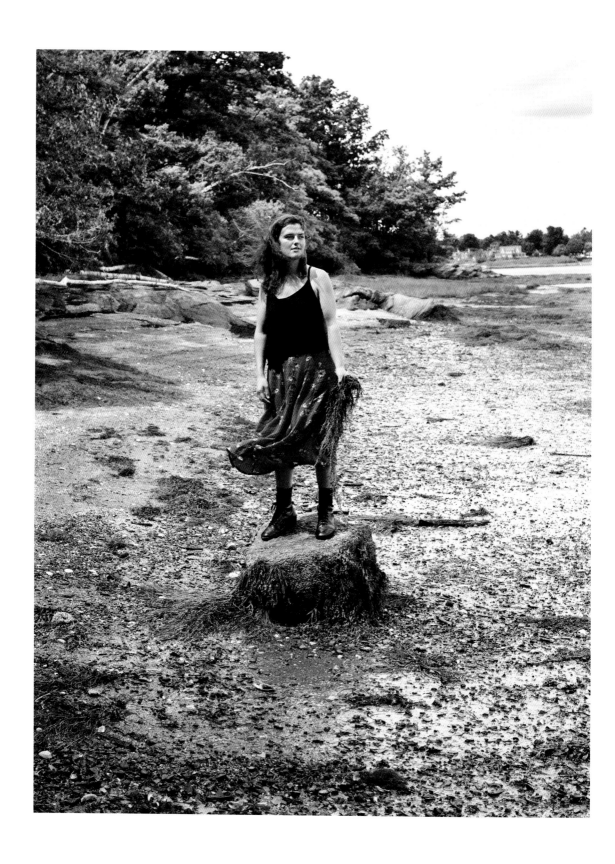

GRACE (PORTLAND, MAINE)

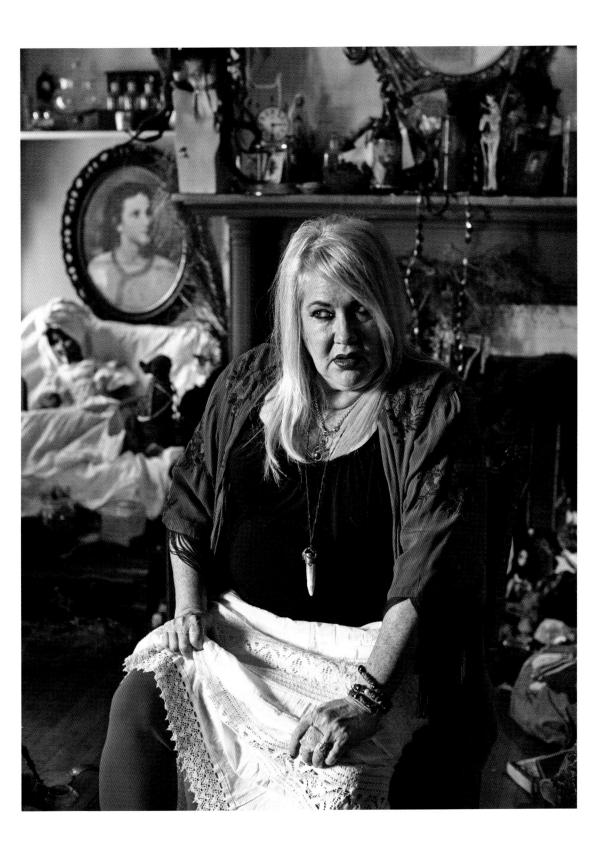

BLOODY MARY (NEW ORLEANS, LOUISIANA)

A lot of what the word "witch" means to me is based on the history I've unearthed [in the process of writing a book on flower essences] around the wise women healing tradition in Europe. I'd always known that "witches" were unfairly persecuted by the church in Europe and North America, but I never knew the full extent of it. Through studying the historical roots of witchcraft, I've come to understand it as a healing tradition connected to ancient wisdom that was passed down from Indigenous traditions. My ancestry is Euro-American, and in the European folk tradition, so-called witchcraft was simply folk medicine. During the Middle Ages and Renaissance, the dominant medical framework was a blend of science and spirituality—for instance, alchemy and astrology were part of medicine during this time—and there was nothing taboo or occult about it. As the church and ruling classes came into greater power in Europe, capitalism began to emerge and reorient the entire medical profession to be privatized, male-dominated, and under the jurisdiction of the church. Women in the healing arts became scapegoats, vilified simply for being women who possessed healing abilities, and ultimately for being women. The persecution of women during this time was nothing more than extreme misogyny carried out by the emerging patriarchy.

—Heidi Smith

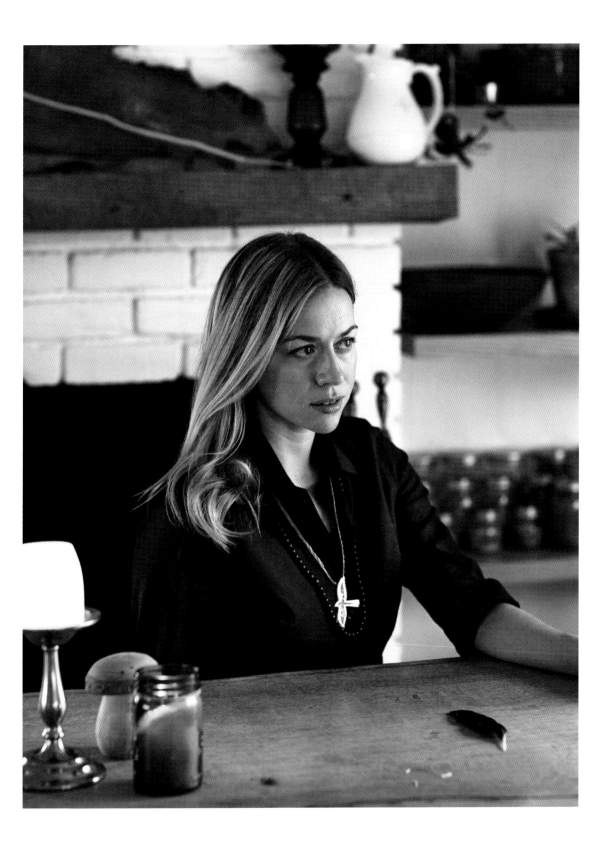

HEIDI (DOBBS FERRY, NEW YORK)

TOMB (OAKLAND, CALIFORNIA)

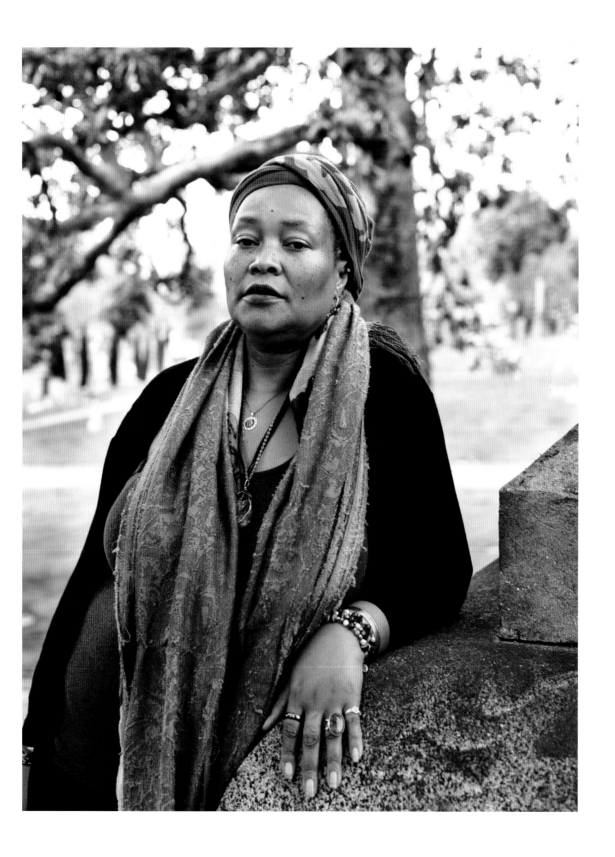

LUNA (OAKLAND, CALIFORNIA)

For me, it was like falling in love. It happened slowly, and then all at once.

I started to become aware of nonapparent forces after several years living in New Orleans. There is a pretty strong occult community there, which I always thought was weird and had nothing to do with me, until I needed it. It's a dangerous city, but I was maybe too young to feel like I was in danger until a particularly violent summer when the crime started closing in on me. I was hearing gunshots at night. A delivery boy was stabbed on my front stoop and then my apartment was broken into.

I couldn't sleep there anymore, so a friend of mine came over and did a *veve*, a Haitian Vodou ritual where you create a drawing on the ground with corn flour to draw in the presence of a certain spirit. The desperate fear I was feeling allowed me to be open to the healing that took place that day. It showed me how empowering ritual could be—that if you were feeling lost and out of control, you could perform a symbolic action that would summon your personal power and get you through whatever was happening.

Vodou has been a part of my life ever since, seventeen years now.

—Cristina Black

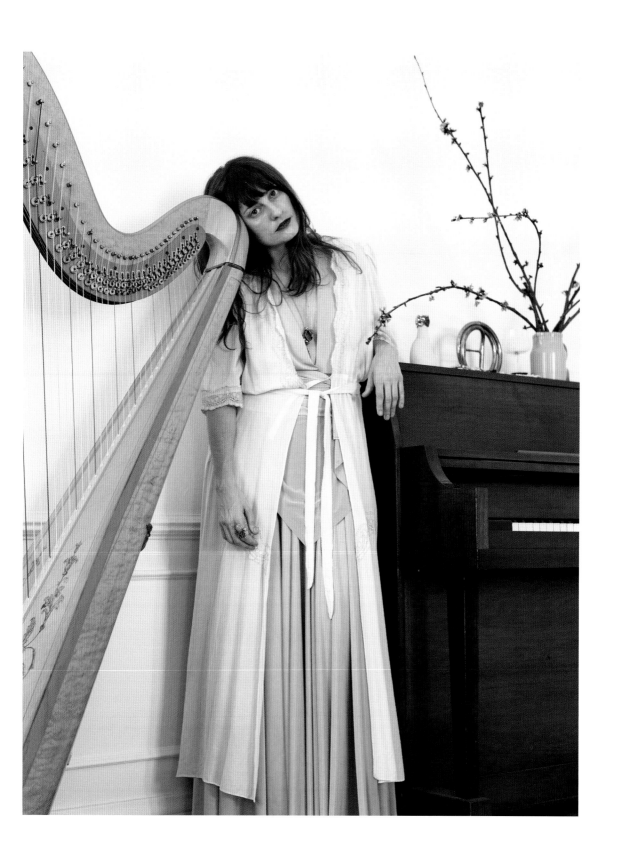

CRISTINA (LOS ANGELES, CALIFORNIA)

FAIRY HOUSE (MACKWORTH ISLAND, MAINE)

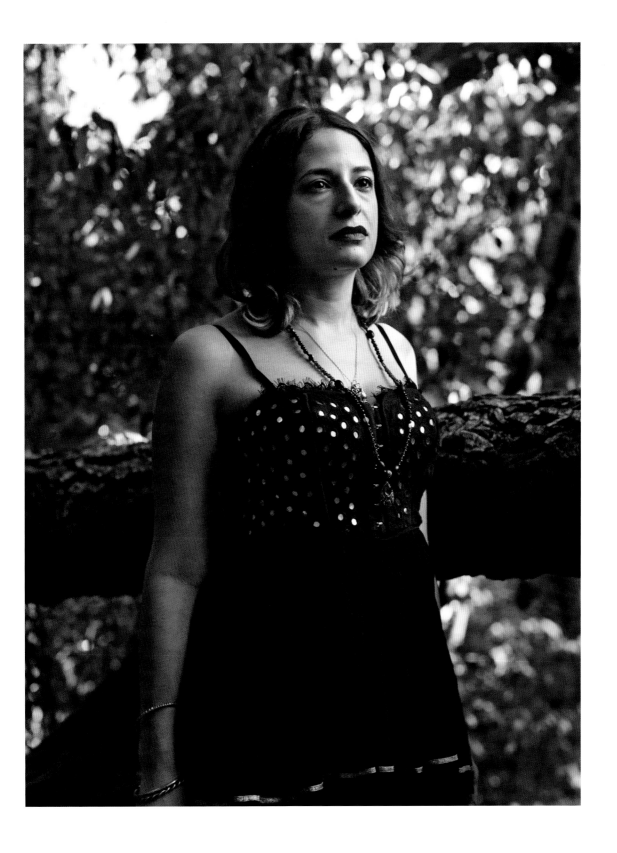

NATALIE (BROOKLYN, NEW YORK)

I was born into witchcraft. Literally, my parents conceived me in a tantric sex ritual. They claimed I chose them, so as a teenager when I was unhappy with them, they said I had no one to blame but myself.

As long as I can remember, my mom studied the tarot and kabbalah, practiced astrology, and was a member/student of the esoteric group B.O.T.A. (Builders of the Adytum). Later she became a Reiki master and a sound healer. As much as I remember participating in commercial holidays as a child (i.e., Easter baskets and stockings for Santa Claus), we also went outside at night and did rituals under the moon for various solstices. My mom always made sure I understood that all the major holidays of Western culture were nicked from the Original Ole Time Religion: Paganism. Her words are seared into my brain. She was a funny lady. So, to answer the question, to me being a witch is the same as being Jewish. I am not the strongest practitioner of either of my faiths; I just am what I am.

—Jenni Lee

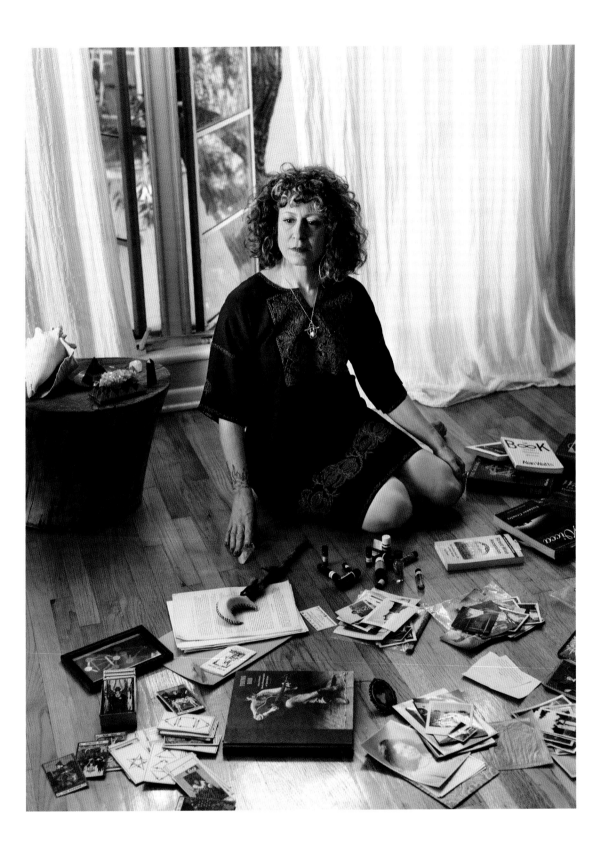

JENNI (LOS ANGELES, CALIFORNIA)

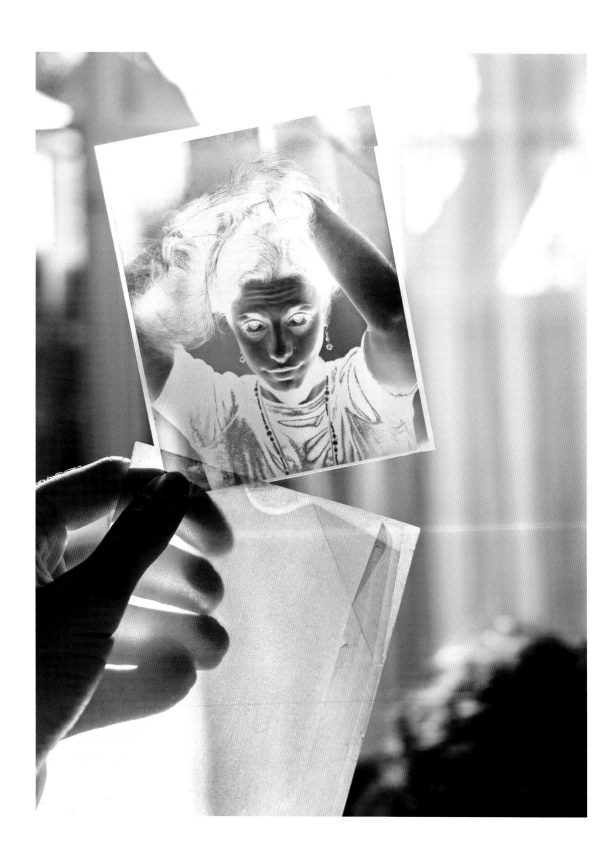

JENNI'S MOTHER (LOS ANGELES, CALIFORNIA)

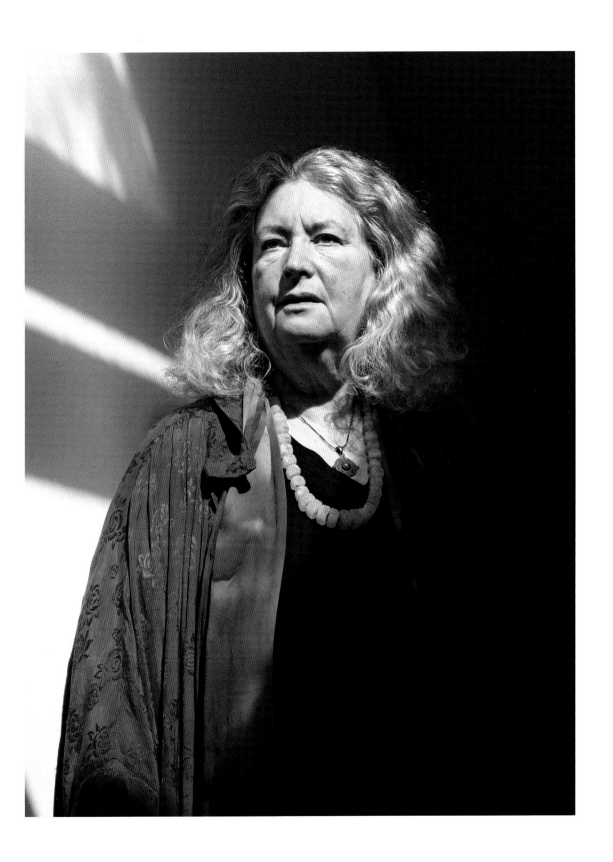

STARHAWK (SAN FRANCISCO, CALIFORNIA)

Around the time I was eleven, I began identifying as a witch—a decision that got me in a lot of social trouble at school. My childhood best friend smelled blood in the water and used my new identity to organize a bullying campaign that still awes me in its scale. Entire groups of girls would rise as one and move away if I tried to sit with them at lunch or in study hall. Parents asked that their daughters be moved out of my classes at school.

My idea of myself as a witch came from exposure to a few objects and stories I can remember and certainly others I can't: my father's high school copy of the *Encyclopedia of Demonology*, recovered from his old bedroom; Tomie dePaola's *Strega Nona* books; a deep love of Halloween; and this surging, mysterious, glittering, dark feeling inside me that belonged to me alone and deserved expression. What my former best friend told everyone was that I sacrificed and/ or maybe did weird sex stuff to animals and babies, and that I was in league with Satan. I was so hurt and confused by the idiocy of her cruelty.

The experience of ostracization writ large at school really confirmed me as a witch, and it stayed with me through middle school and into high school, where my first boyfriend also thought of himself as a witch. I kept an altar up through high school, ruining the flowered wallpaper in my bedroom with my candle smoke.

After I went to college my witchiness was pretty dormant for many years. It was always part of how I saw myself, but I didn't think about or pursue witchcraft particularly actively until I was in my PhD in Los Angeles and in a young marriage that was in trouble. It felt like I was remembering a way of surviving in darkness.

—Lisa Locascio

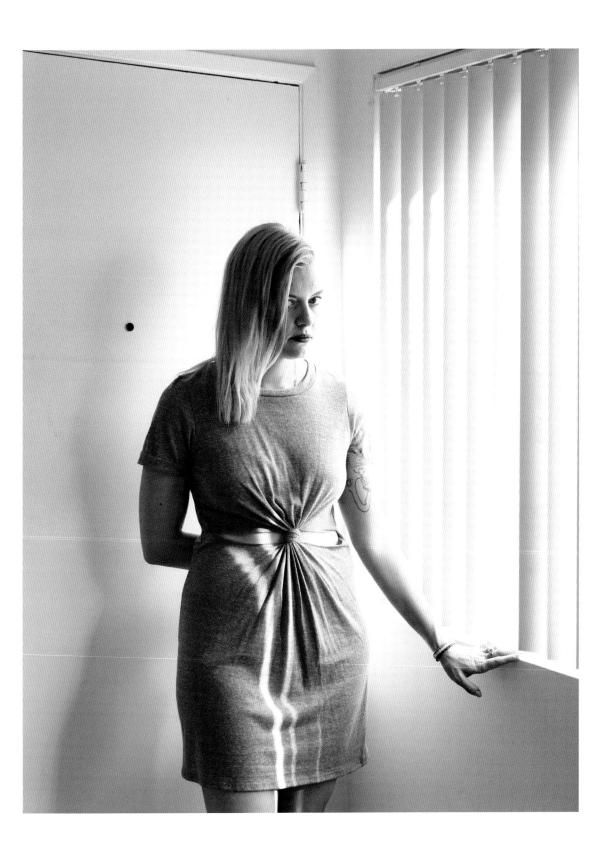

LISA (LOS ANGELES, CALIFORNIA)

When I was younger, I remember there being talk of my aunt being a witch. I remember listening to the opinions of my family members, who are all Southern Baptist, and I can recall a lot of their fear was that she was a "Satan worshipper," and I saw how they ostracized her because of their own fears and lack of understanding of her beliefs.

It wasn't until I became a woman and went through a series of traumatic events that I was opened up to the wonders of the Divine Feminine—which helped me to find my inner magic.

I don't follow one specific practice. Mine is a combination of Christianity, Wicca, Buddhism, and Santeria—as well as connecting with my African ancestry and practices.

—Shy Blunt

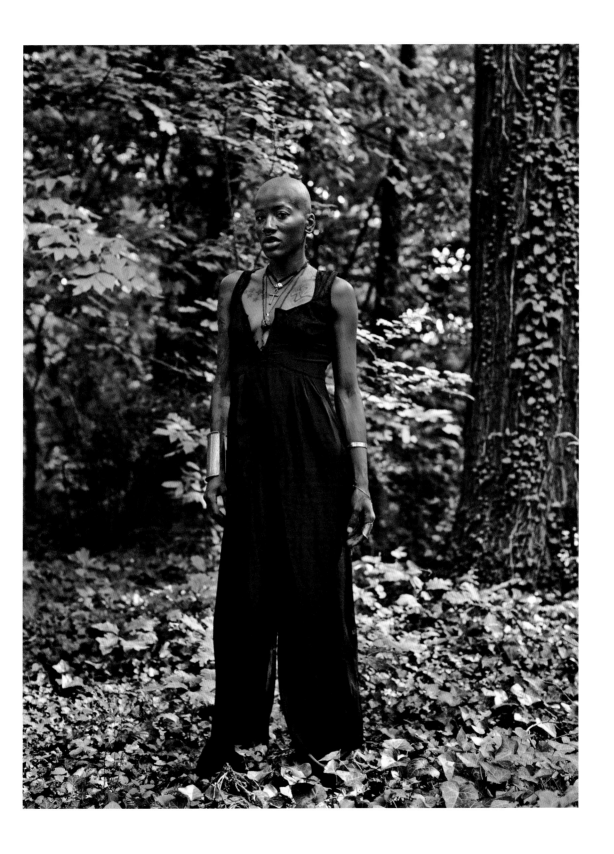

SHY (BROOKLYN, NEW YORK)

We don't like seeing "starter witch kits," as Sephora once tried to put on the shelves. This isn't a damn Disney movie, and our beliefs are not your costumes and accessories. I earned my pentacle at thirteen, earned it through study. All my female allies have. We don't like fake light.

—Phaedras

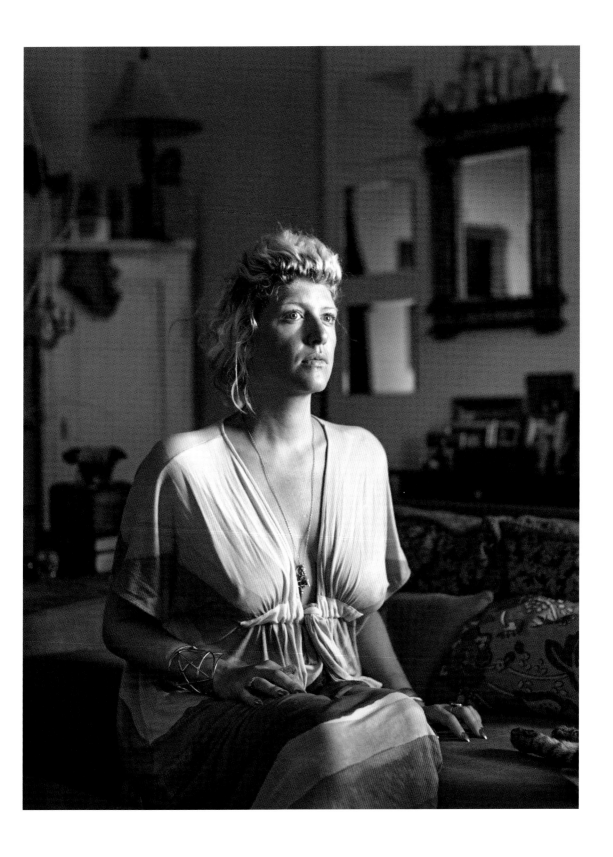

PHAEDRAS (BROOKLYN, NEW YORK)

For me, the word "witch" and my genderqueer identity are linked. Both feel like words that describe a facet of my identity that might once have been hidden, but now I embrace; and both are identities that fit me more cleanly than any other, and that bring me a sense of euphoria and power.

I remember a few years back there was a great deal of controversy over a witch in New Orleans using bones that had washed up from a Black cemetery in their practice. Many (including me) felt it was inappropriate for a white person to use the bones of a marginalized community in their practice as it reinforces a horrible history of oppression and violence toward Black communities and bodies, particularly in the South. It tied into a larger discussion about cultural appropriation, which is a difficult and complex subject in the witch community. The use of white sage by persons who are not of Indigenous descent has skyrocketed, which has made access to white sage by Indigenous communities more limited, effectively prioritizing white witches over Indigenous peoples who use white sage in their own cultural and religious practices. Personally, these controversies have made me more mindful about what practices I adopt and how I come by them. Are these practices that feel natural to me? Why? Am I colonizing spaces by practicing certain things as a white person?

—Keavy Handley-Byrne

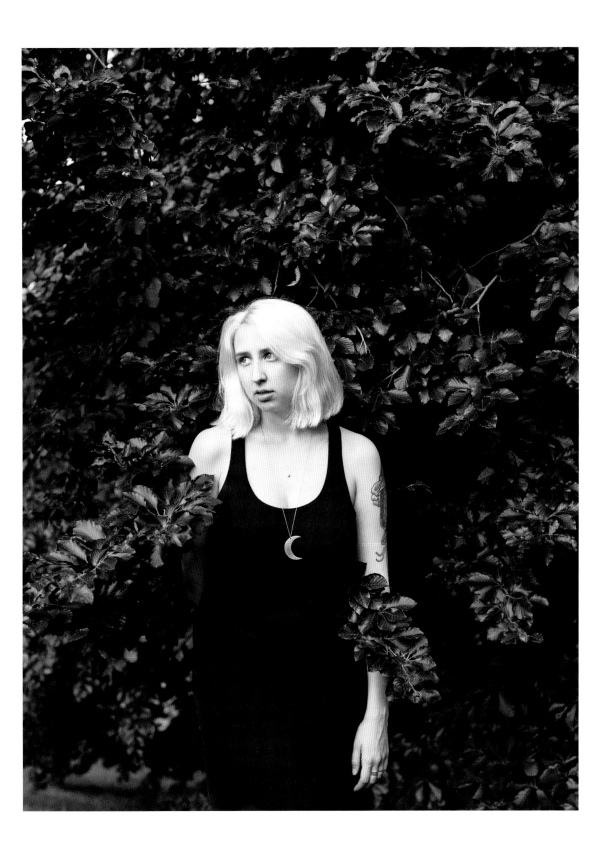

KEAVY (BROOKLYN, NEW YORK)

I am a manbo asogwe, an initiated priestess of Vodou. I was initiated in Port-au-Prince, Haiti, and see myself as serving Bondye—the force of all goodness, the Ancestors, and the intermediary and ancestral spirits, the lwa. I honor the legacy and Ancestry that I access through my Haitian Papa's lineage. I do not see myself as a witch or Wiccan or even pagan, though the lwa are seated in the natural forces around us. They are the natural forces that sustain us, the Ancestors who stand behind us, and the spiritual guides who lead us forward. I recognize an Invisible realm of spirit that informs, interacts with, and influences the visible world.

Vodou ceremonies are a technology for opening the door between these worlds and inviting spiritual powers to interact with us. There are themes of resistance and redistribution of power inherent in the act of accessing and inviting invisible sources of power out into the physical. It was so for enslaved people: in spite of their bodies being in hell, the life force itself could reach out to them, for those who had eyes to see into the Invisible.

—Sallie Ann Glassman

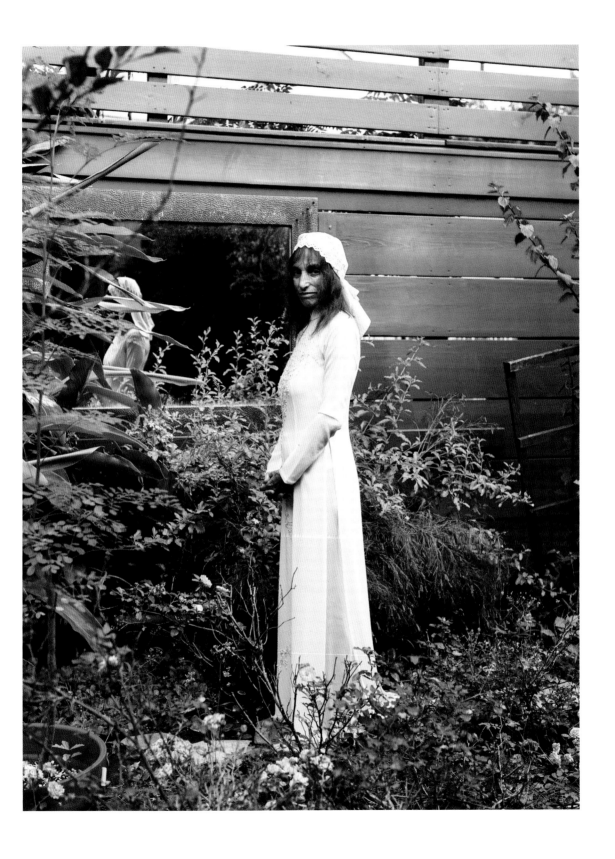

SALLIE ANN (NEW ORLEANS, LOUISIANA)

I feel myself as a witch in the way that I hold space for my students, clients, friends, and family. I feel like in a witch in the way I always relate to the moon, to the trees, to plants and herbs. I feel like a witch in my hair, and face, and clothes I wear. I feel like I'm a witch in the way I read signs and listen to messages from the world around me. A witch is not afraid of the shadow side of life, meaning she is able to go to hard and deep places in herself and, in turn, she is able to stay steady and spacious with these hard feelings in others. The witch cares and loves. To be a witch is to be a woman who is embodied in practices that are both mystical but also very real and human. I feel like a witch in the way I care about human rights and nature and feel the fury and the burn at injustice and cruelty. I feel like a witch in the depth of my heart and my deepest intuition.

—Deborah Claire Bagg

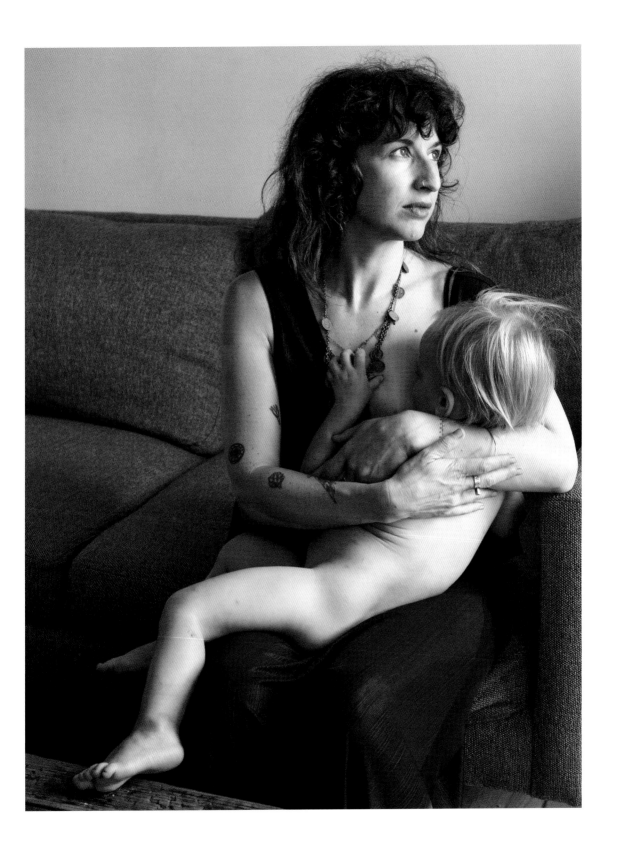

DEBORAH (BROOKLYN, NEW YORK)

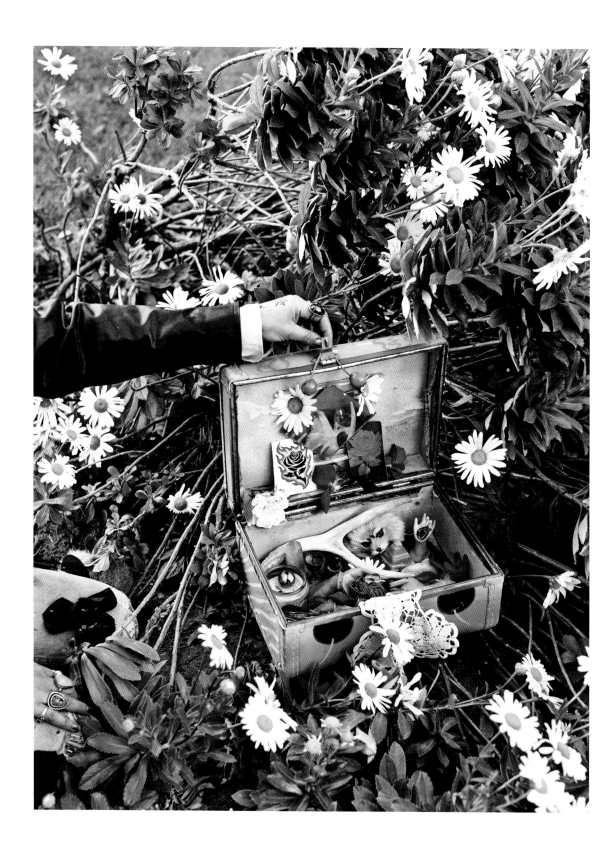

STREET ALTAR (BROOKLYN, NEW YORK)

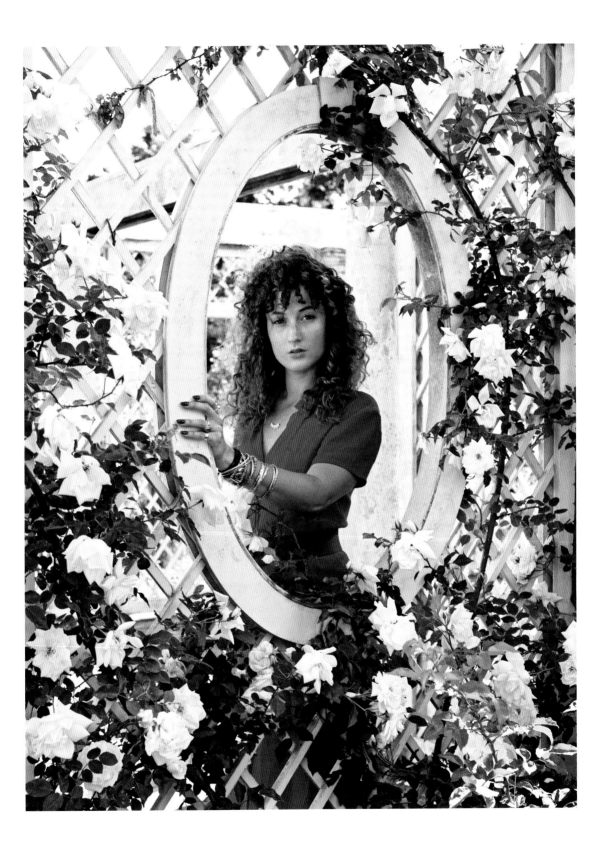

ALEXANDRA (BROOKLYN, NEW YORK)

I can't think of a time when I didn't know I was a witch. As soon as I could articulate who I was at all, I was identifying with that word. As far back as I can remember, I was collecting sticks, stones, and bones and setting up altars, talking to the trees, trying to move the clouds.

Everything I do has a little of the craft in it. I work as a massage therapist, yoga teacher, meditation guide, cartomancer, and chef. Some of my clients come to me for altar-based spell work, some for therapeutic bodywork, some for nourishment. I wear a lot of hats, and not all of them are pointy, but witchcraft is in everything I do, whether I'm healing, guiding, or feeding a soul.

—Diana Lynn Duane

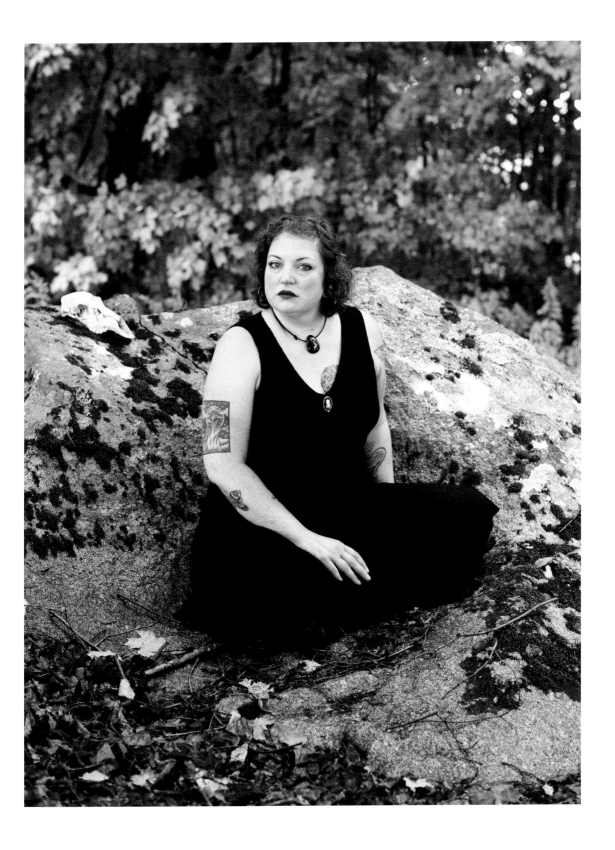

DIANA (ETNA, MAINE)

I'm from a long line of Witches. I'm an Indigenous Taino Medicine Woman and *bruja*. I belong to my tribe, Higuayagua Taino.

Anyone that meets me will see what I'm able to see, hear, do. When I was a teen, I didn't know how to control what would happen around me. Spirits that I'm able to see and communicate with would bother me while I was in school, making things move and telling me things I needed to tell certain people. I was used by teachers and adults for my gifts. I didn't want to be that person. I wanted it to shut off and for me to be normal.

I tried to commit suicide a couple of times until I realized I wasn't supposed to go. It wasn't my time. Who I was, was not changing. I needed to accept my witch and protect myself. So instead I started to use my gifts to help people. And that's when it started to feel like I could live this way.

Now, I'm an author, the owner of a botanica, and an activist for Indigenous rights.

—Juliet Diaz

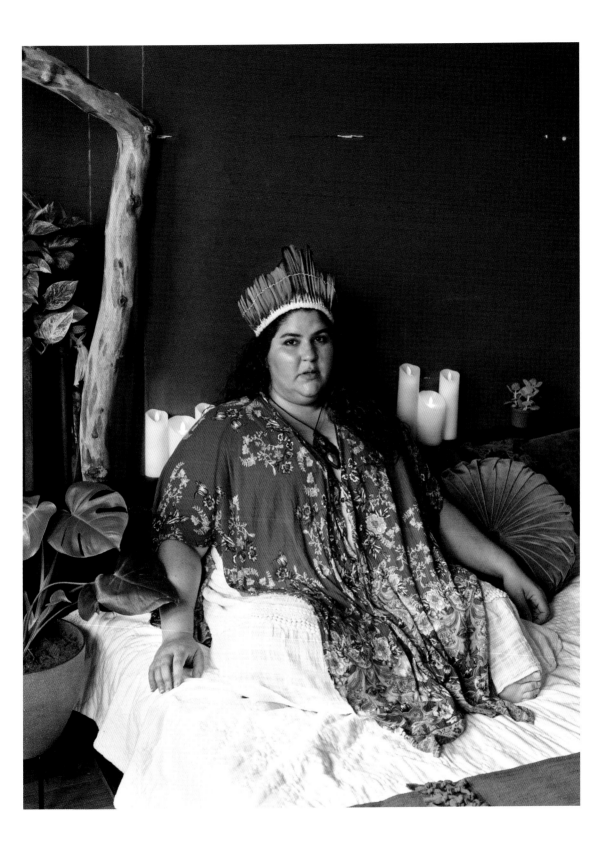

JULIET (JERSEY CITY, NEW YORK)

I "came out of the broom closet" to my extended family about twenty years ago. One cousin reached out to say, "Me too!" Nobody else said a word. One aunt asked if I was in a cult, but she seemed more curious than negative. The outside world hasn't felt particularly hostile, but I live where weird is normal. I am now the High Priestess of a Celtic Pagan community. As a classical Chinese medicine practitioner, I deal in energy, potions, ghosts, and magical change. I could also call myself a Green Witch or Hedge Witch.

The first time I attended a women's spirituality festival, I participated in a shamanic journey to meet the goddess Brigid. When it was over, I couldn't stop crying, and a wise gentlewoman held me. I said, "I want to be a witch when I grow up." And she said, "You'll never grow up, and you already are a witch." To be seen like that was profound. Several years later I started my own Circle. After we had been having Moon ritual for a year, my soul-sister did a "re-ordination" ceremony for me because she insisted that I had been a priestess before and was simply reclaiming it now. I felt a profound sense of self-acknowledgement in that ceremony. See it, name it, be it.

—Gina Martin

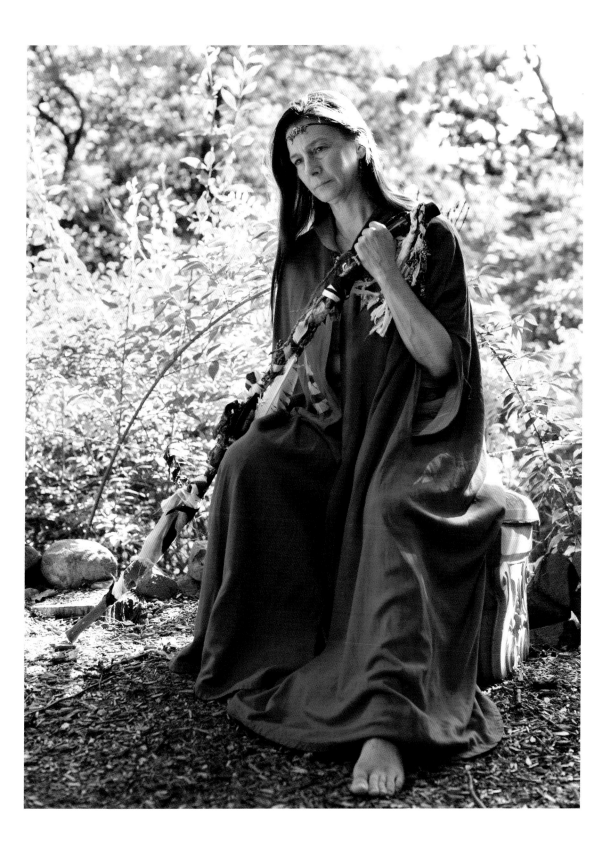

GINA (SUFFERN, NEW YORK)

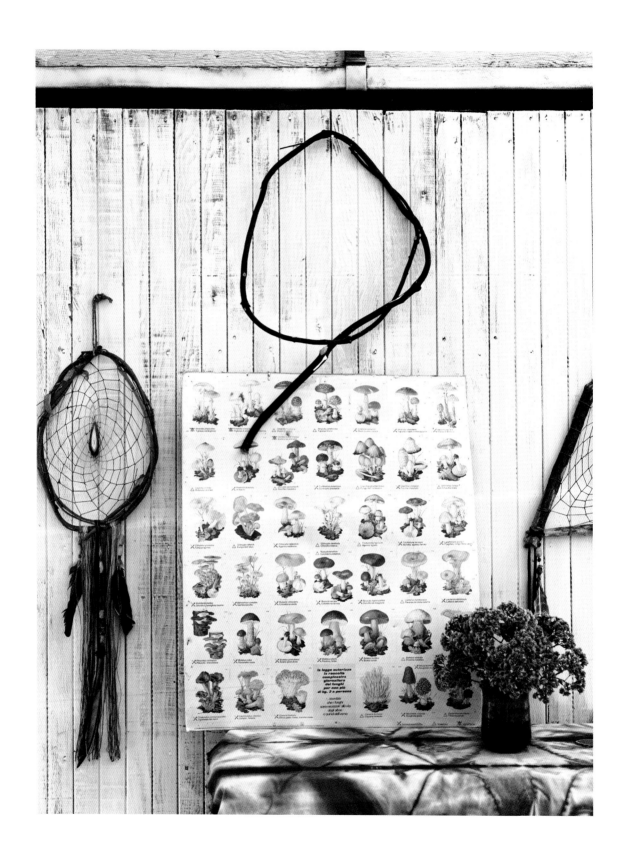

FUNGHI (LOS ANGELES, CALIFORNIA)

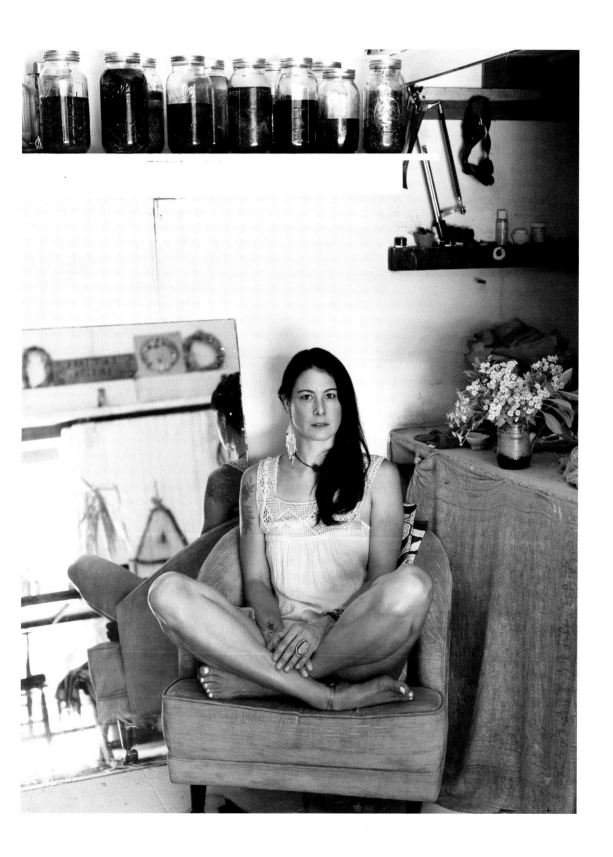

KARI (LOS ANGELES, CALIFORNIA)

My initiation was a very moving experience for me. It was just me with my teacher and two of her associates. I underwent a few weeks of intense study, isolation, and was given chores that I didn't comprehend the importance of until much later. At the end of the intensive, I created an altar and was evaluated with complicated scenarios and questioning. It was an exhausting, confusing blur. But at the end, to my surprise, they informed me that I had successfully completed my Green Witch initiation!

—Lata C. Kennedy

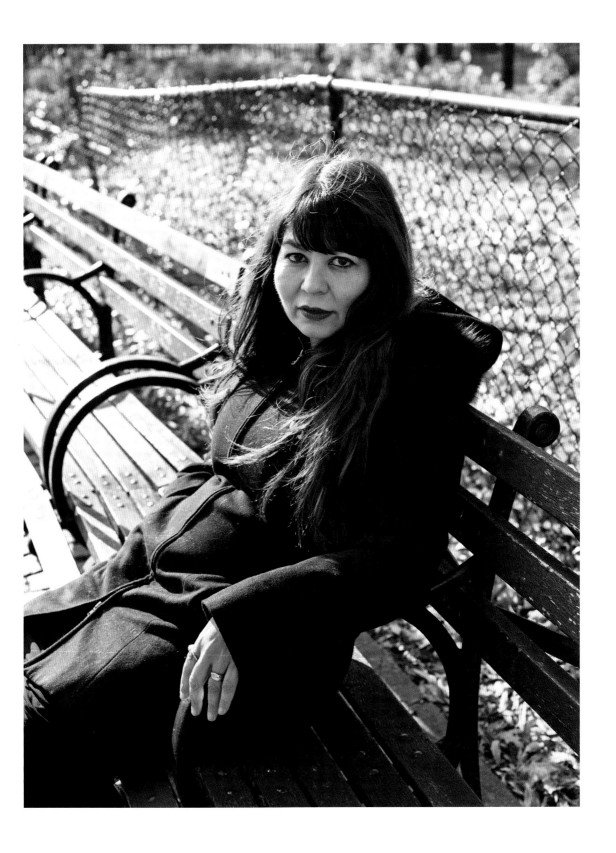

LATA (NEW YORK, NEW YORK)

[I have been discriminated against for being a witch] more times than I can count. I was dismissed from my job because I was told that if I did not remove the word "witch" from my website, I would not be permitted to teach there any longer. Under threat, I was told not to tell people my religious orientation. My choice was to resign. I receive email threats reliably from Christians around every two months, and I get sexual threats from men around as often. I have been attacked and harassed in person after public performances by both females and males and told that my soul is damned to hell. It is really something. Some people, once they find out I'm a witch, literally stop talking to me and walk away. But I'm also more than blessed with the number of people who find it positively delightful and want to know more about it.

There are still some states that have laws against practicing divination, the mainstay practice of many witches. Due to this prohibition, in a country that claims to have freedom of religion, I would say it has become political. The United States military in a Supreme Court case recognized Paganism as a religion only in the last few decades, but many Wiccans, Pagans, and members of Earth-based religions are [barred from] performing clergy rites. When a religion is persecuted by government officials, I'd call that political.

—Maja D'Aoust

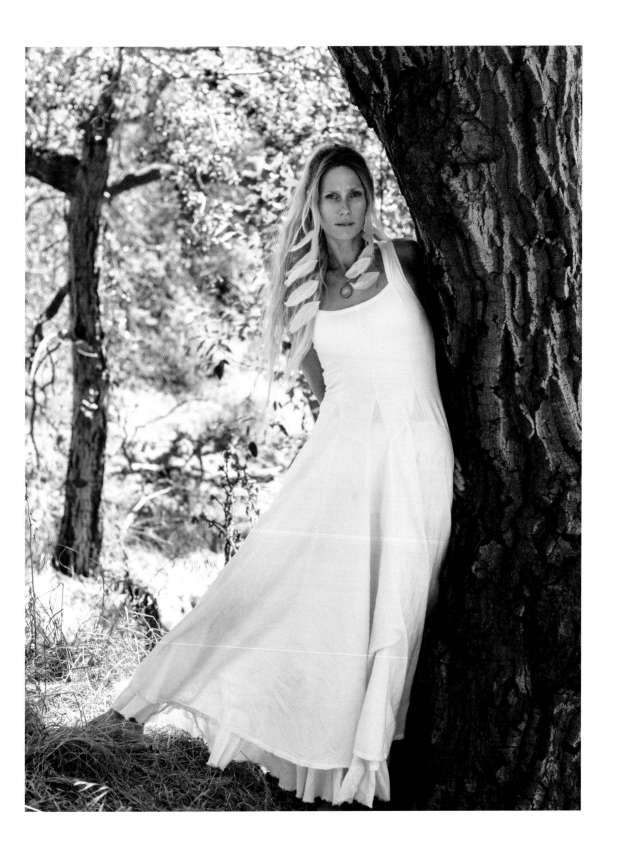

MAJA (LOS ANGELES, CALIFORNIA)

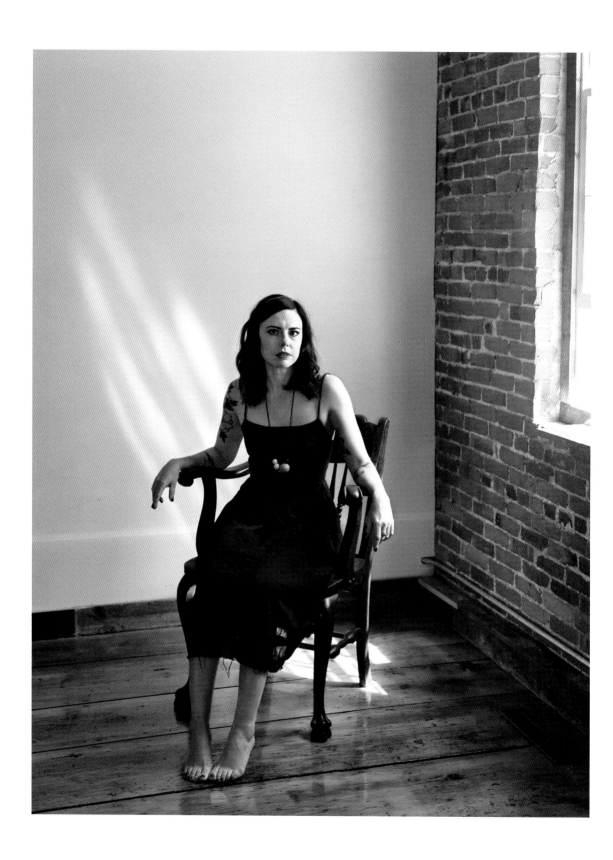

ERICA (SALEM, MASSACHUSETTS)

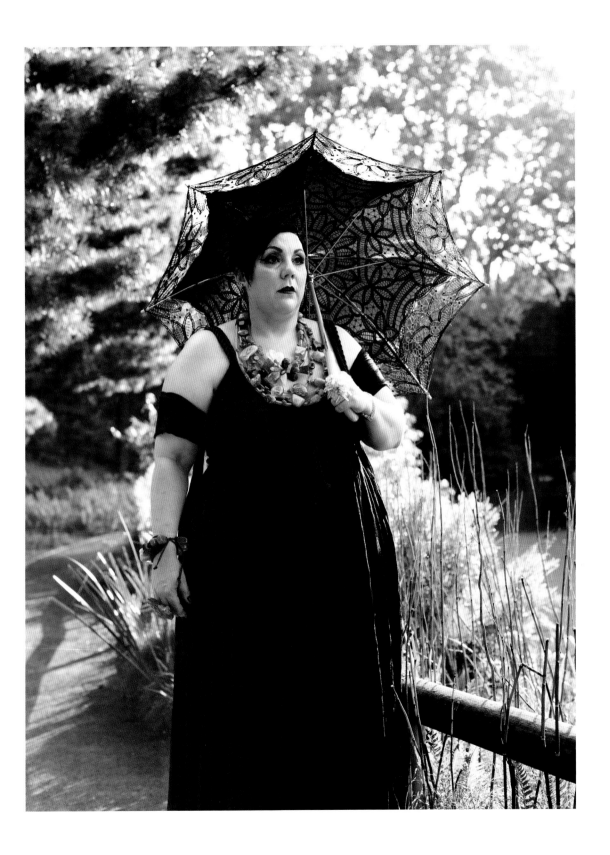

TARA (BROOKLYN, NEW YORK)

We can talk about cultural appropriation forever. But people have been trading and sharing their tools, medicines, ceremonies, and celebrations since the beginning of time.

We still do this today, but the key is having reverence and acknowledgment. For me, one of the most hurtful things in the witchcraft community are terms like White Witch and Black Magic. These carry strong racial connotations behind them. "White" meaning good, healing, pure, and often used to describe European folk magic, while Voodoo is always referred to as Black Magic (especially in movies and television) practiced in communities of people of color. "Black" meaning bad: hexes, curses, and sacrifices. In reality we need balance and duality. Shadow work is just as, if not more, important than "love and light" practices, but not as popular, especially with some of today's witches who want a pretty, curated experience.

—Staci Ivori

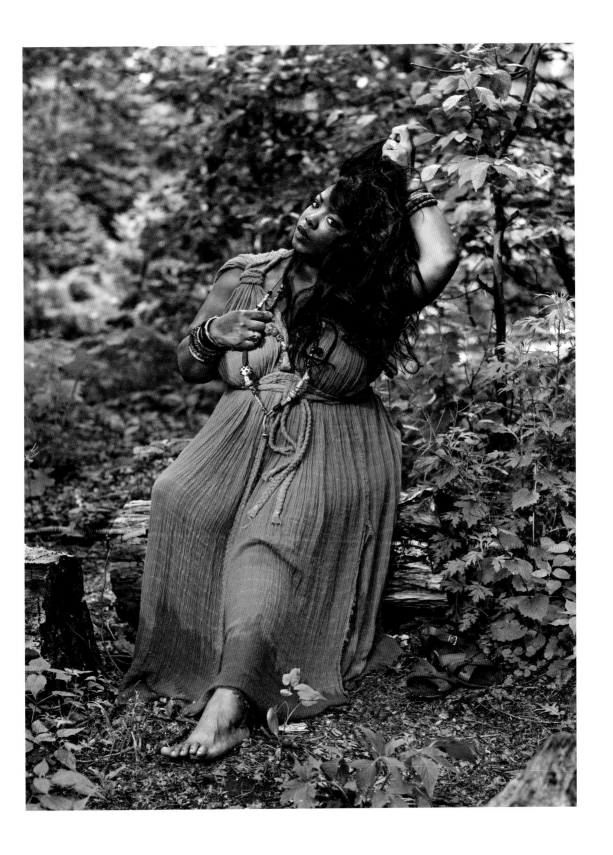

STACI (BROOKLYN, NEW YORK)

I was studying Silvia Federici's book *Caliban and the Witch: Women, the Body and Primitive Accumulation* in college and became fascinated by the political idea of a witch. After graduating, I began studying Starhawk's *The Spiral Dance*, but quickly discovered that I aligned with it spiritually. I began to believe in magic and consider myself a witch.

My practice has evolved a lot over the years. Several years ago, I was heavily into "dark" magic, hexing an abuser of mine regularly and fascinated with the idea of spiritual revenge. I no longer work that kind of energy because I have begun to believe in energy as a vibration that is constantly circulating. We are all connected to each other. Now, I mostly work with the moon, ancestors, and supernatural presences in my home to manifest my wishes and hopes for the world.

—Raechel, also known as Mima Good

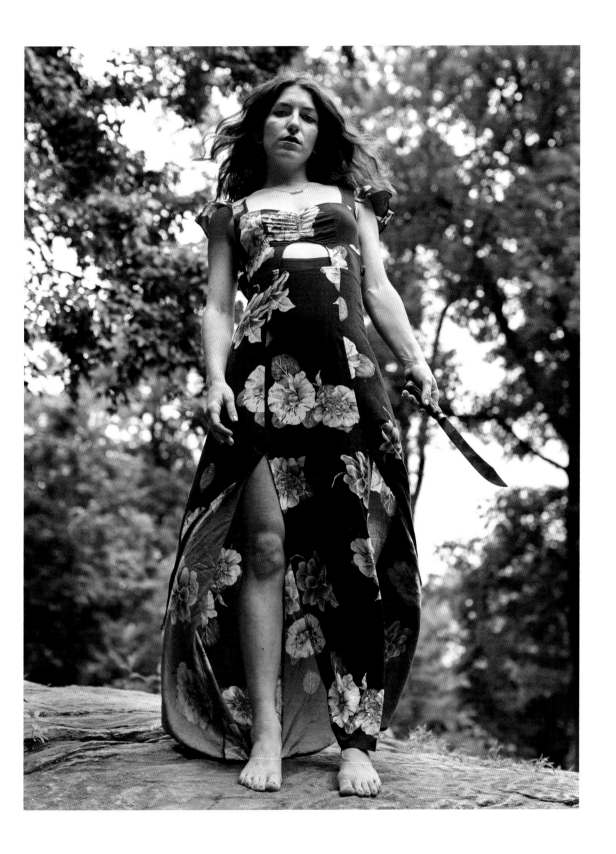

RAECHEL (NEW YORK, NEW YORK)

I was eight when I saw an ad in a magazine for Gavin and Yvonne Frosts' *The Magic Power of Witchcraft*. I put my allowance money in an envelope and mail-ordered it. (Hey, it was San Francisco in 1976.) The Frosts even corresponded with me (through snail mail, of course) to answer my questions, and liked that I was a little witch! My Italian-Catholic dad made me throw the book away, telling me it was evil. I think he was being a bit theatrical—after all, he would go on to help me with some spell work, including putting one of my bullies "on ice." I was nicknamed Strega from that point forward.

I started with Wicca and now have my own Bast temple. I often work with my cat Selket, and the spirit of my Siamese familiar, whom I named Isis.

You could say I'm a cat witch.

—Serena Toxicat

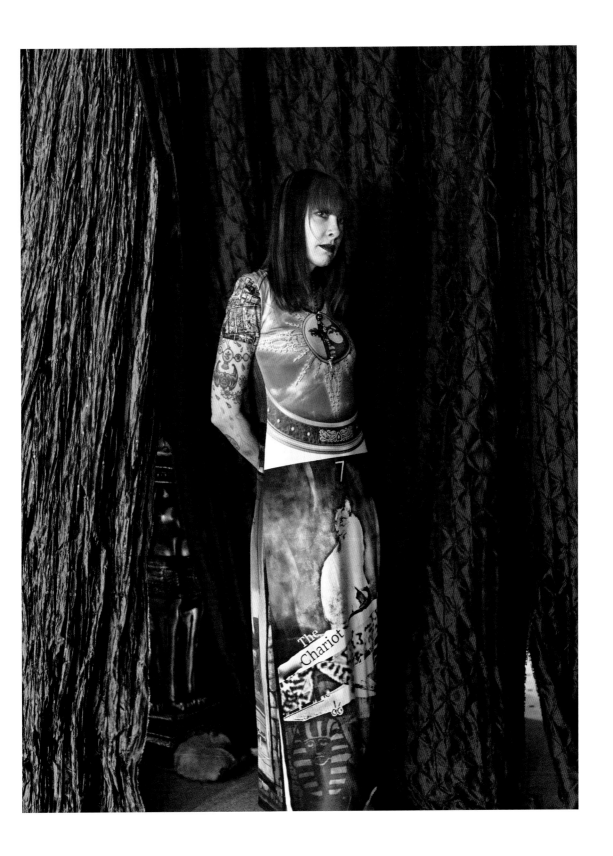

SERENA (OAKLAND, CALIFORNIA)

My path to embracing and identifying myself as a witch has been very spiralic, and a lot of it is rooted in my relationship to being an intuitive. All folx are intuitive, but to be an intuitive is a really different thing. Intuitives really see, feel, and hear what others cannot, and have access to a kind of invisible web of experiences and information, much of it flowing back and forth from the past to the present to the future. I was an extremely psychic, sensitive, empathic little kid. I recall feeling overloaded much of the time as a child and knew that I was connected to unseen things that I couldn't explain or bring language to.

I was also unfortunately raised in an extremely physically and psychologically abusive situation. The combination of the trauma and grief of the abuse, mixed with the unique intensity of being a psychic child, really opened my hands to God at a very young age. I was always seeking that sense of Source and Divinity, something that could help me to both cope with the pain of my childhood and bring greater understanding to what was happening inside my body and channel.

Because I was raised Catholic, I tried to seek a sense of connection with the Invisible there, but it always kept me wanting. It wasn't until I stumbled upon a book about Wicca at the age of fifteen that my entire world blew open. I was reborn. It was the first time that I had ever read anything about Source that felt like it was in my language. It opened my soul to Nature being my teacher, to the Wheel of the Year, and the spiralic rhythms of life. It reconnected me to something that I knew even then had walked with me in many lifetimes. Wicca saved my life, and blessed me with a sense of power, prayer, and spiritual connection that aided me greatly in my suffering and PTSD as a teenager. It only continued to blossom from there. I am not Wiccan any longer but wouldn't be here without the initiation of that experience.

—Lindsay Mack

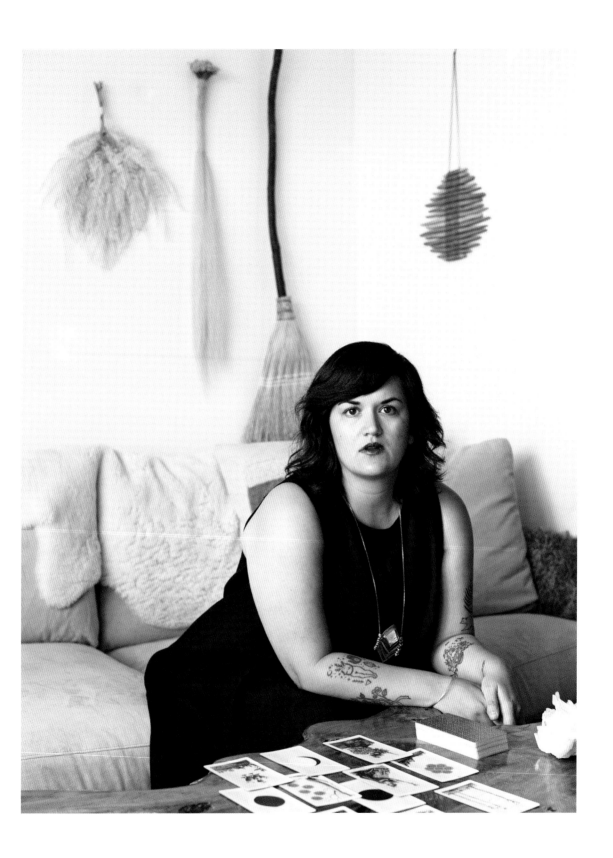

LINDSAY (BROOKLYN, NEW YORK)

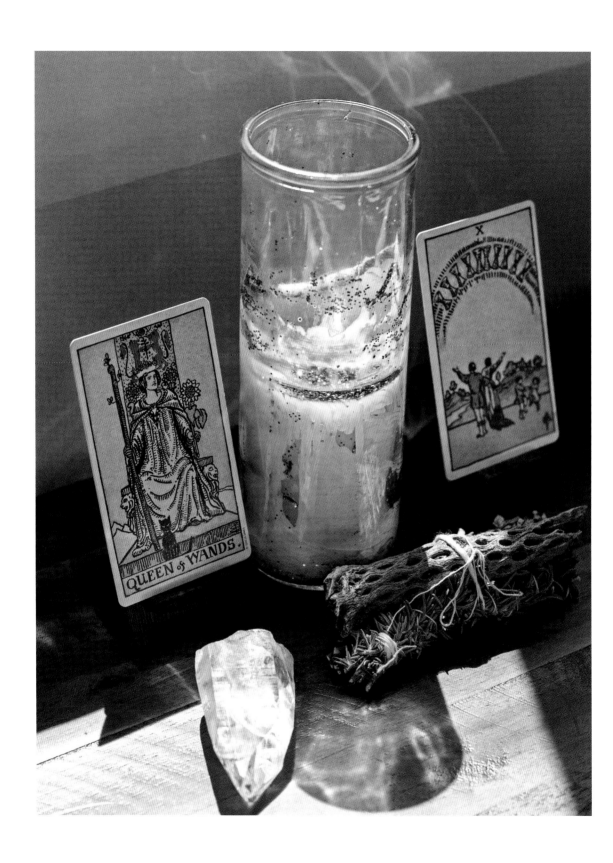

PULLED CARDS (BROOKLYN, NEW YORK)

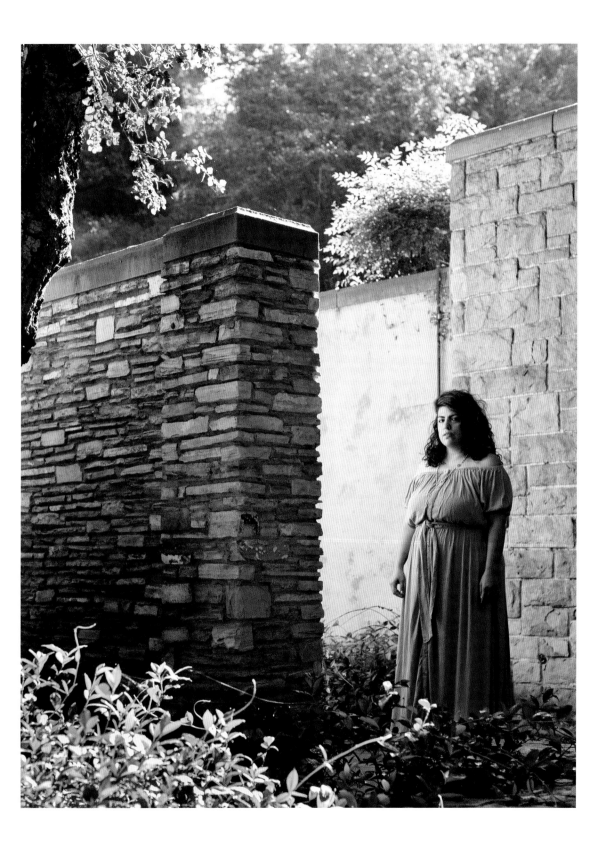

NADIA (LOS ANGELES, CALIFORNIA)

As far as witchcraft is concerned, these days I operate pretty much as a solitary. But I do run my own New Orleans–style Voodoo house. I have several students, or godchildren, and we come together for rituals, ceremonies, and workings.

It's hard to define Voodoo in a few sentences. You can spend your whole life learning, practicing, studying, and elevating. The word itself means "spirit" or "deity," but on every level defies definition. It is based on the concept of Ashe, the universal life force existing in all things. Most practitioners do not also consider themselves witches. I do because that is where I began my formal study. It has stayed with me over the years and I continue to honor it.

There are many controversies in the witchcraft community. Many of these revolve around race, gender, and exclusionary practices. I have written extensively about cultural appropriation regarding the African Traditional Religions and also witchcraft. These are complex issues and I hope everyone is mindful of the practices they engage in. I'm not gonna call anyone out by name, although I could.

—Lilith Dorsey

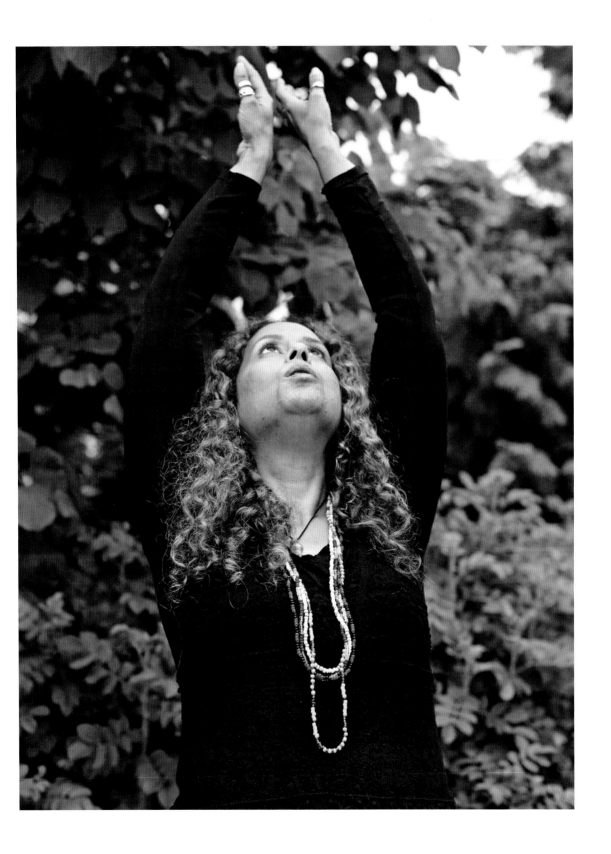

LILITH (BROOKLYN, NEW YORK)

The feuds within the occult community are historic. There have been major tensions between specific groups I've been a part of that, by association and extension, go back to the mid eighties. There is plenty more controversy going back further than that, or at least that's the lore. This is one reason why it's easier to practice alone, in my opinion. I'm retired from the classic battle of Who's the Biggest Baddest Witch. It grossly lacks authenticity and accountability to be stuck in that part of the ego—and is antithetical to personal growth.

—Blue June

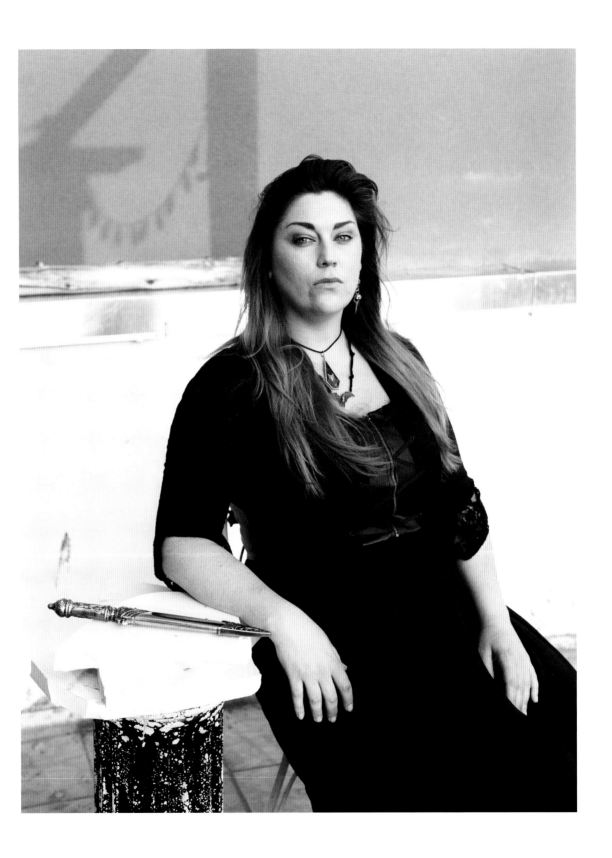

BLUE (BROOKLYN, NEW YORK)

I have never doubted the presence of magic, and I've always communicated with the natural world around me, both seen and unseen.

Growing up in rural New Hampshire, the lady's slipper orchids and garden snakes felt as much my kin as humans did. I spent a lot of time alone and didn't question the normalcy and validity of speaking to the elements around me. The nuances of nature's seasonal changes and cycles were in my blood.

In the spring, I planted seeds and drank maple sap straight from the buckets hanging on the trees. Come summer, I would soar above the fields with the hawks, forage for mulberries and wild grapes, and collect yarrow and calendula for the healing salves that my mother would make. Autumn brought the harvest, crunching golden leaves, and preparations for the long nights ahead. Winter was icicles, evergreen boughs, and candlelight, the scent of beeswax and pomander balls.

All year long, I ran through the forests and marched across mountain streams with a band of like-minded wild child spirits. We explored abandoned cabins in the woods and spent hours hiking reservoirs, collecting feathers, stones, and bones. Snakes, frogs, and forest creatures were our familiars. We watched beavers build their dams and fed wild strawberries to turtles. The cosmos arranged and rearranged themselves, aurora borealis streaked across the night sky . . . the power of the earth, the universe, was undeniable. Why would I not speak directly to all of it, tell it of my sorrows, ask for support and guidance?

—Phoebe Autumn

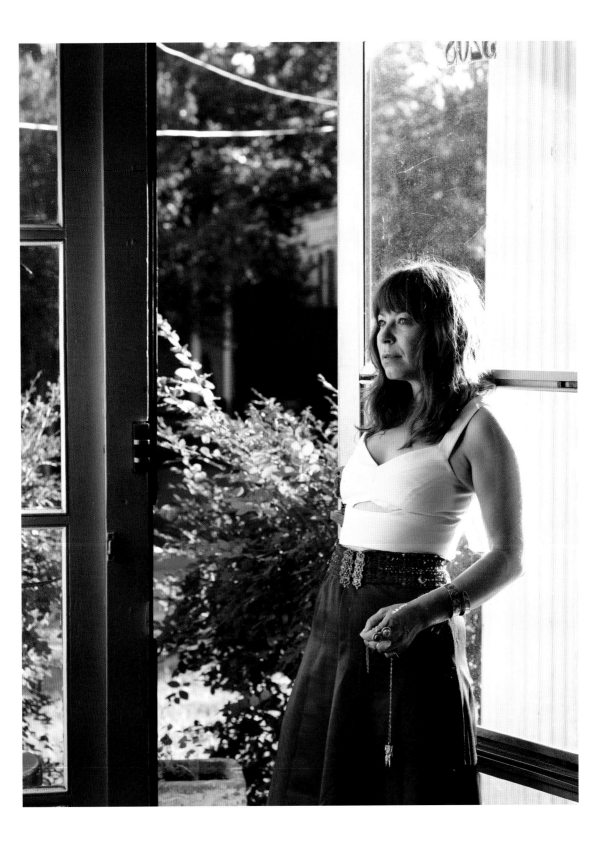

PHOEBE (NEW ORLEANS, LOUISIANA)

When I became a feminist, I realized our movement didn't have any spirituality. Feminists resented religions—they hurt women too much. I had to explain over and over how religions are not the same as spirituality. It wasn't until I decided to apply some of my spell-casting skills to cut the luck criminals depended on when they raped or murdered a woman. There was the Freeway Killer on the loose; he had killed six women, and the police had no leads. Our fledgling coven, the Susan B. Anthony Coven Number One, decided to hex the killer's sorry plans and allow the weak link to identify him. This came to pass when the killer's cousin was arrested for shoplifting, and under interrogation by the police, the truth came out that he was just an enabler to his boss, the killer himself. They found his tools and torture instruments, and the killer was arrested and put in jail for a very long time.

This is when the feminist community suddenly understood how the spirit world can be helpful to the living. Feminist Witches gained respect. This was the start of a now very global Goddess Movement.

—Zsuzsanna Budapest

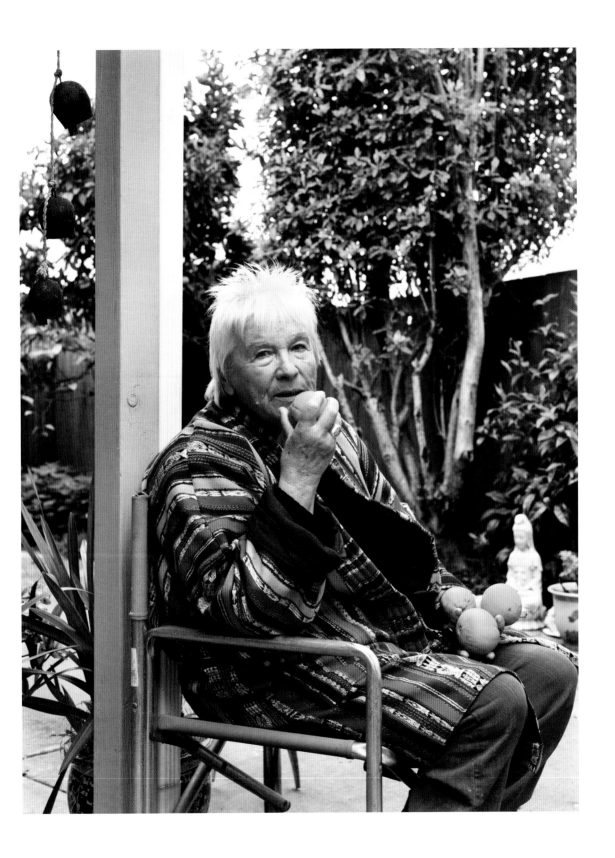

ZSUZSANNA (WATSONVILLE, CALIFORNIA)

Witchcraft informs my worldview. It's intensely political to believe in the oneness of life on Earth. You can't do harm without harming yourself in the process. In light of the magnitude of harms being done through our politics, holding this belief can be pretty overwhelming. But for me, the hopeful part of that idea is that you can't heal yourself without contributing to a greater healing in the process.

—Mya Spalter

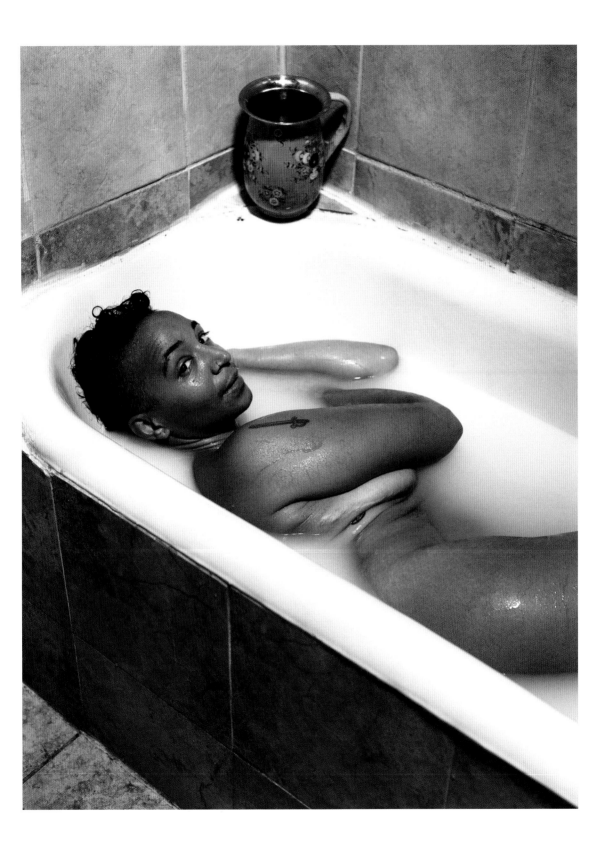

MYA (BROOKLYN, NEW YORK)

I am part of a coven called the Coven of the Black Pearl, who practice an anarchist style of witchcraft. Most of us in the coven fall under the umbrella of practitioners of Reclaiming Wicca. I also call myself a hedge witch.

I have come to understand there are grave responsibilities that come with the power that lies in witchcraft. Regardless of what methods or traditions work for you, the more you practice, the stronger you become at manifesting things, and sometimes if you're not extremely careful about what you call in, things can go awry. It's very important to be aware of what power you wield and the ethics behind how you direct it.

Now more than ever, it is time for us to band together to fight our shared enemy, the destruction of our planet, our home, our living, breathing Mother Earth. We are running out of time. Yet we seem to be caught up in wasting time bickering about whose tradition is whose, who has the right to claim what title, to practice what tradition, even to wear what clothes or play what instruments. At this time, when we need to speak as one, we are becoming more and more divided.

—Meredith Muse

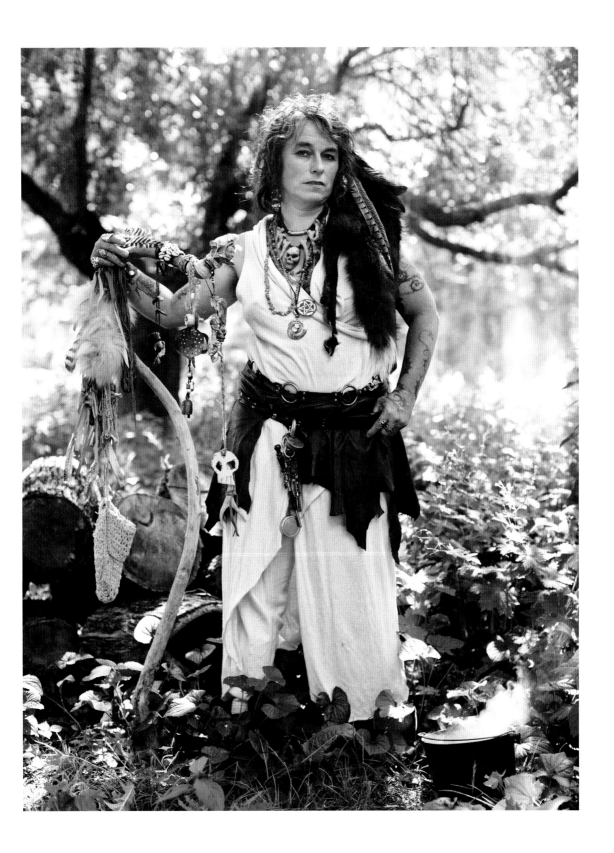

MEREDITH (MORETOWN, VERMONT)

FOREST HIEROGLYPHICS (BROOKLYN, NEW YORK)

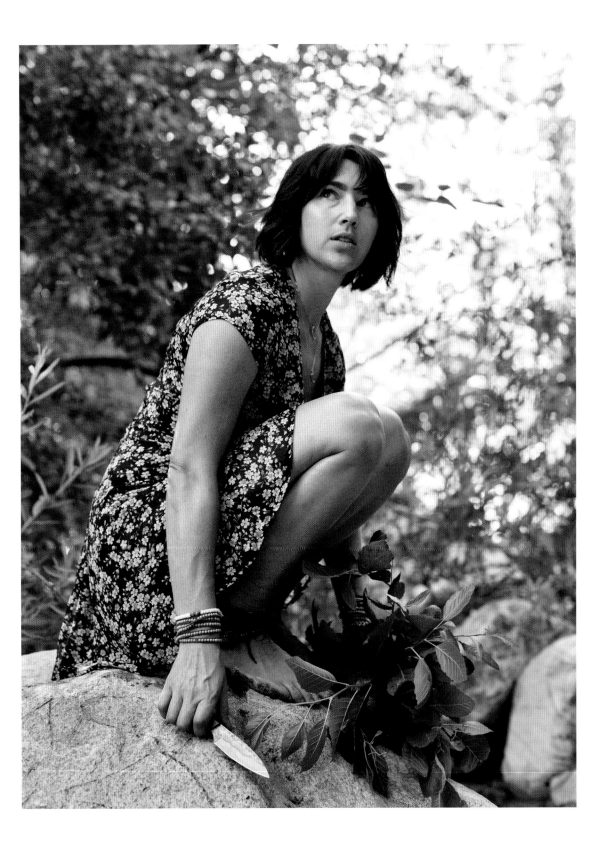

REBECCA (MENTON, CALIFORNIA)

I had a psychedelic experience with 4-MeO-PCP (an experimental research chemical) that I took immediately following an LSD trip in 2010. It was like two perpendicular planes intersecting—the trip was like nothing else I've ever experienced. I looked out the balcony of our London flat and could understand how the bay trees were communicating to each other through the wind. Then I began communicating (chirping!) to the birds. I learned that they were protector spirits and that there would be "their kind" upon my arrival back in NYC as well. The trip moved on to a powerful vision of a persecuted witch frantically climbing up a church clock tower, hoping to escape her fate. When I came back down from the trip, I started crying when I recounted the witch vision. As I spoke, I just knew it. I was a witch.

"Witch" means so many things to me, but I think most profoundly it is a way of being in conscious co-creation with the universe, of finding ways to manifest will through power with (rather than power over, as Starhawk writes) the natural world. That sense of flowing with the forces around you, and of the interconnectedness of all life is fundamental—which makes witchcraft, in my mind, inherently political. That way of being is in direct conflict with much of the Western paradigm (and its associated institutions) as it stands now.

—Britta Love

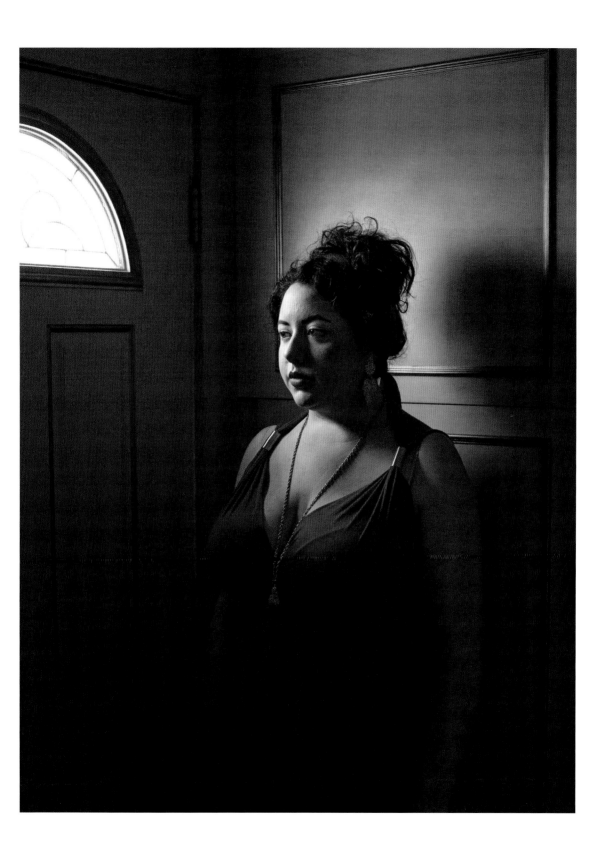

BRITTA (BROOKLYN, NEW YORK)

Before my snakes slithered into my life thirty-five years ago, I had lost touch with my sensual wild nature and life purpose due to physical illness. Yet entwined in my snakes, I experienced a profound healing in my Body-Mind-Soul. Their soothing serpentine undulations all over my body restored my equanimity; my ability to feel joy, sensuality, and well-being amidst my pain and life's conflicts.

I am a snake priestess or nature witch, one who recognizes the power of awe: respect, fear, and wonder in the presence of something sacred. I collaborate with many who are Wiccan as well as Indigenous, Goddess-oriented, and laypeople.

I define priestess as a verb, as in priestessing or facilitating an experience. Some prefer to see me as an interspecies facilitator with a specialty in boa constrictor snakes.

—Serpentessa

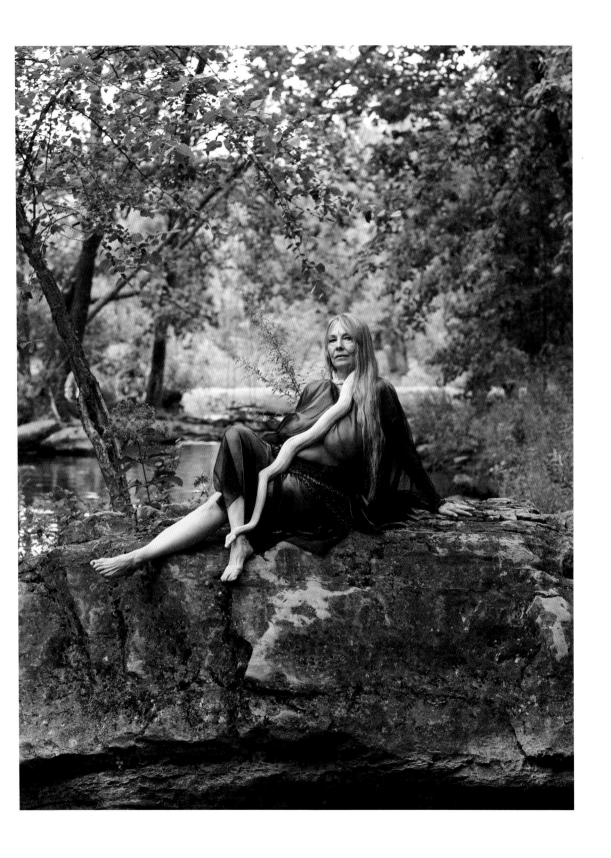

SERPENTESSA (ESOPUS, NEW YORK)

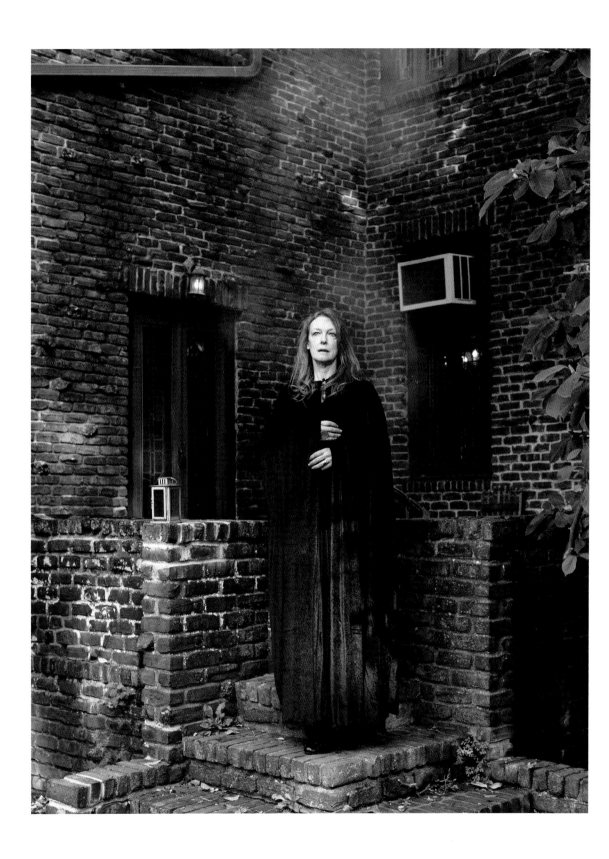

DEBORAH (NYACK, NEW YORK)

A Conversation with
Horace D. Ballard and Frances F. Denny

Horace D. Ballard, PhD, is Curator of American Art at
the Williams College Museum of Art.

HORACE: As you know, I am perennially interested in a photographer's process—whether they make, make, make, and only weeks or months later, realize they have begun a new series with a new set of intentions, or whether they prescribe limits for themselves, beginning and ending a project consciously. Do either of these models feel truthful to your process? And do you see a conceptual through-line in your work as it proceeds project to project?

FRANCES: My process primarily reflects the latter scenario. I spend months developing and investigating an idea before I even pick up my camera. That was certainly the case for *Major Arcana*, the initial spark for which came many years earlier. In 2012, while researching the series that became my first book of photographs (*Let Virtue Be Your Guide*), I made a surprising discovery: it turns out my tenth great-grandfather, Samuel Sewell, was one of the central judges in the Salem witch trials, and coincidentally, my eighth great-grandmother was accused of witchcraft only twenty or so years prior in another Massachusetts town. As someone who grew up in New England and has been long fascinated

by that particular moment in U.S. history, uncovering my family's connection to (and complicity in) the trials struck me as something I might want to revisit in future work—so I mentally tucked it away. In 2015, I read Stacy Schiff's historical account of the trials, *The Witches: Salem, 1692*, and was reminded of my familial link. And so began *Major Arcana*.

When I revisited my ancestral connection to Salem, I began thinking about who and what the archetypal witch is—and who embodies her today. I had some awareness that there are people who identify as witches but I knew very little about the modern witchcraft movement. The inquiries that emerged from that initial spark were: What does the archetypal witch figure represent? Who calls herself a witch today; who does that identity belong to? What does a practice or belief in modern witchcraft entail? I began answering these questions first by researching the landscape of contemporary witchcraft (Margot Adler's *Drawing Down the Moon* was of particular help, as was *The Spiral Dance* by Starhawk, who I was lucky to later meet and photograph), which, as it turns out, isn't a discrete community so much as a kind of quilt made up of differently sized, interwoven, overlapping fabrics. My hope is that this book responds to that initial inquiry by offering a collective portrait of the modern witch.

As for a through-line in my work as an artist, from project to project my work examines the influence of familial, historical, and sociocultural forces on female identity. I'm interested in looking at the ways in which we succumb to—or fend off—guises of performed femininity, and how those guises (or expectations) do and do not change over time. From series to series, I'm working to reveal this interplay by imaging women within different frameworks. *Let Virtue Be Your Guide* was largely about questioning the traditional, buttoned-up femininity that my New England female relatives embody. *Pink Crush* reframed feminine signifiers from '90s pop culture. *Major Arcana* unearths the proto-feminist archetype of the witch, positioning the modern witchcraft movement as a defiant, feminist reclamation of a long-maligned word.

HORACE: What was your relationship to the word, archetypes, and stereotypes of "witch" before the project? What does "witch" now mean to you?

146

FRANCES: Like most, I came to the idea of "witch" compromised by the usual stereotypes. My family's connection to Salem was front of mind, but so too were the stereotypes originating with the European witch hunts beginning in the fifteenth century, then the Brothers Grimm fables and other folklore, followed by *The Wizard of Oz*, several notable Disney franchises and Hollywood ad infinitum. When we think of a witch, we often imagine a black pointed hat atop a green, hooked nose, perhaps a gnarled finger beckoning children further into a foreboding wood. That, or a flame-haired seductress. The witch has long been the antagonist or meddler in fairy tales and heroes' journeys alike. There are those that bend the rule (Glinda the Good Witch, Samantha of the television show *Bewitched*, and even Sabrina the Teenage Witch), but none come very close to accurately representing the modern women (and yes, men) who identify as witches today.

I'm depicting the witch differently, stripping away the stereotypes we associate her with and revealing what is at the heart of this shadowy archetype. By re-rooting the word in the individuals I photographed, I'm allowing for a new definition of "witch" to emerge in my viewer's mind, as embodied by the real women who claim "witch" for themselves. And though some of my subjects certainly flirt with some of the expected witch signifiers (there is a certain profusion of black cloaks!), most complicate our stereotypical notion of the witch.

The concept of "witch" is found in many cultures and societies around the world (*bruja, strega, sorcière*)—she's a common figure, a historical scapegoat for societal ills. It's easy to associate the archetypal witch with the Other. Society fears the Other, thus she is marginalized (I recommend Barbara Ehrenreich's book *Witches, Midwives, and Nurses: A History of Women Healers*, which delves into this idea in fascinating ways). Though the people accused of witchcraft in Salem would no sooner have identified themselves as witches than as ears of corn or skeins of wool, it's a popular reading of what happened in 1692 that many of the people accused somehow posed a challenge to societal convention. As for the witches I've met in the last several years, I would say that in my experience a modern witch is maybe a little (or a lot) anti-authoritarian, and is interested in examining the murkier, less conventionally acceptable sides of herself. She is usually a person with a good deal of self-possession.

HORACE: What struck me on a first encounter with the words and the text are the wide cross section of humans and perspectives you've managed to give face and space to. How did you find these individuals and what was the process of selecting the locations where you met them?

FRANCES: Nearly every person photographed for this series came by referral from another subject. I did meet some individuals organically—and some I scouted at witchcraft festivals and even on social media—but the project largely grew out of meeting an early handful of people who agreed to be photographed, who then in turn introduced me to others.

Your impression that *Major Arcana* represents a multifaceted representation of witchcraft is central to the project. The answer to my initial query (Who and what is a modern witch?) is effectively: anyone who chooses to be. As the portraits suggest, there is no single way to be a witch. I've photographed Wiccan High Priestesses, practitioners of Voudou and Santeria, Neo-Pagans of all stripes, green witch herbalists, hedge witches, kitchen witches, sex witches, activist witches, and word witches—as well as occultists, mystics, spiritualists, artists, tarot readers, and astrologers who feel connected to "witch" as an identity. "Witch" isn't one thing. (I typically refer to my subjects as "witches," but there are religious Wiccan Witches who prefer to use an uppercase "W.")

The word "witch" contains multitudes. Layered within it is a long history of the subjugation of women, plus the common stereotypes that dwell in the collective unconscious and reveal some fairly universal biases about the feminine. At the same time, "witch" possesses an intrinsically female canniness. I use the word "female" frequently in reference to this project and my subjects—which include genderqueer and nonbinary individuals—because of the undeniable connection to female identity that the archetype retains. "Witch" is a moniker both broad and specific, locating its host first within a history of violence and oppression, then a countercultural fringe, and finally a celebratory, defiant reclamation. It's a malleable, changeable, roll-your-own kind of identity, but also can be incredibly specific. Wicca, for instance, or Voudou or Santeria, are religions that have their own pantheons and particular spiritual frameworks (note that Wiccans are

typically thought of as pagan Witches, while practitioners of Voudou and Santeria don't usually refer to themselves as witches, but within the context of this project have identified with the archetypal notion of the witch).

HORACE: In the epigraph chosen to open the volume, you quote Margot Adler's sense that the power of the word "witch" is derived from its imprecision, that it frames not just a person or experience or act, but an archetype. Likewise, the words that accompany the image of Dia Dynasty speak to the conscious and unconscious intentions in containers and labels as a means of control, but how do you consider the ultimate imprecision of such labels and containers?

FRANCES: Labels and containers help us define ourselves and enable a sense of belonging with an identity, group, or other affiliation (like "vegetarian," "activist," or "addict"). They allow us to feel a part of something, but alone don't speak to the fullness of an individual. Labels can also be violent when used against someone. In regard to "witch," I see it is as a reclaimed word, much in the way "queer" was reclaimed by the queer community as a term of pride. The people photographed for this project define themselves in relation to that word but also embody many other things, in the same way as I see myself simultaneously as an artist, photographer, and mother.

HORACE: It's been nearly ten years since we first met and shared life histories, educational trajectories, and understandings of photography. Across the varied approaches and intentions behind your series, *Let Virtue Be Your Guide*, *Pink Crush*, and now *Major Arcana*, you maintain a distinct sensibility vis-à-vis portraiture. Might you say a bit about your approach to the portrait as a genre of representation—the ways you find it a generous and generative medium, what it does not allow, and how you work to push the limits of its form?

FRANCES: Portraits are endlessly mesmerizing to me because they ask questions rather than answer them: Who is this person? What can we know about them given the information included within this frame? What does the quality of light reveal or obfuscate? The psychology inherent to a portrait captures our imaginations, allowing us to read clues and come to our own conclusions.

The photographic portrait is unique in that it captures a fleeting glimpse of a person as they really were, but—and here's the catch—the photograph's frame is exclusionary by definition.

The trouble with photographic portraiture is its reductive nature: it is impossible to render an individual in all their complexity within the confines of a static frame. Yet I also believe whole-heartedly in the expansiveness, psychological import, and even magic of the medium. Gesture, visual metaphor, and even mystery all work to generate a gut feeling in the viewer that can transcend time and space to become a deeply personal experience. However, to represent a three-dimensional flesh-and-bones human being in a single dimension is by definition a diminution of the multiplicity of the individual—particularly when viewed within the framework of this kind of portrait series; i.e., these are witches in America. There is something sacrificed by the multi-dimensional individual for the sake of their one-dimensional likeness, especially when seen as part of a collective portrait such as this. Add to this the fact that women have arguably been the most sexualized, objectified, and commodified subject of the male artist's gaze throughout cultural history, and we see that the moral stakes behind creating a representation of a woman at this point in time are very, very high.

By giving my subjects agency in how they are depicted in their portraits (I collaborated with them on the details of their portrait shoots), I'm working against both the reductiveness of the medium, and also my own power as the storyteller—I want my subjects to help bring color to their individual narratives. I'm hugely grateful to the people who agreed to be a part of the project, contributing both their time and countenances in service to this series and, in some way, sacrificing some degree of their own individuality for the sake of being a part of a collective portrait.

HORACE: As far as the actual act of photographing goes, what are you looking for while taking a picture of a person?

FRANCES: Much of what I do as a photographer is to work with my subject to undo the ways they have learned to perform for the camera. As soon as most of us

set foot outside our front doors, we are wearing a kind of protective mask—our public-facing persona, if you will. I'm interested in uncovering something that is usually hidden behind an automatic smile, an arched foot, or a pouted lip to reveal something open and authentic about each subject. By the time my camera comes out and I begin to photograph a person, there is an intuitive exchange taking place between my brain, eyes, and fingers in reaction to my subject. That internal calculus is based on what I know about this person, where we are, the quality and characteristics of the available light, and how the subject responds to the camera.

People are so much more "camera-ready" these days, what with selfie culture, Instagram, and the simple fact that most of us are moving through the world with a camera on our person. I like to think I guide my subjects into letting go of those ways we shield ourselves from being vulnerable and bare. Most of us hold tension in our bodies in general, and nothing makes that tension more apparent than a big, fancy camera pointed at you. In many ways, this process is about earning the trust of my subjects—it actually requires it. And that begins from the first moment of contact (whether by email or in person), long before the shoot itself. I think this process results in portraits that are more authentic to the individual; they aren't simply pretty renderings of the usual masks we wear in public.

HORACE: The representations and words of Barbara and Keavy raise the efficacy of, and assumptions around, witchcraft, gender, and race. What was it like encountering those perspectives?

FRANCES: Today, as we witness a new wave of feminism cresting, one characterized by political activism, #MeToo, anti-racism, and intersectionality—not to mention a certain cultural trendiness and the resulting whitewashing and corporatizing of the movement—witchcraft is becoming relevant to the mainstream. That isn't a coincidence. The modern witchcraft movement parallels the feminist movement in several ways. While second-wave feminism swelled in the '60s, so too did goddess-worshipping pagan religions that privileged the feminist cause. Nowadays, both witchcraft and feminism are newly of interest to millennials and Gen Z. To publicly be a witch invites disparagement in some parts

of the U.S.—so too with being a feminist. As "feminist" is a nebulous, shifting term, so too is "witch"—their meanings are defined by each bearer individually, and are politicized in the very communities they help create.

I'm glad both Barbara and Keavy (and several others) spoke so candidly about some of the controversies that are currently swirling through the witchcraft world, which falls victim to these types of clashes just like any other spiritual or political group. It's interesting to witness both the feminist and witchcraft movements suffer from growing pains as they are taken up by new generations. One issue that intersects directly with the feminist discourse is the transphobia that is prevalent in some witchcraft circles—i.e., who gets to call herself a woman? I was personally shocked to discover transphobic attitudes in a couple of my subjects (as in, "only women can be in this coven, and a woman is defined as having a uterus, so no trans women would be welcome to take part"). I considered taking out a portrait of one of my subjects because I was offended by her viewpoint—she's a very polarizing figure (she is very influential in the community, but her opinions have been exclusionary and deeply hurtful to others). But the more I considered removing her from the series, the more I felt that it would be sanitizing the conversation. I also fundamentally don't believe that when I make a portrait of someone, it means I espouse or condone all of my subject's viewpoints and actions. So that picture remains in my book.

A well-worn topic within witchcraft is the sensitivity over the mainstreaming of what was once a very fringe, countercultural movement. I asked many of the older witches I met—some of whom have been practicing many decades— their opinions about the recent trendiness of witchcraft, which you see being commodified even by major consumer brands like Sephora (which in 2018 began marketing "starter witch kits" complete with crystals, white sage, and a tarot deck that was met with such fury that they pulled the product before it even hit shelves). And though I certainly came across some resentment over it—one witch bemoaned the "millennial entitlement" she saw watering down her sacred practice—the larger sense I got was actually that if the mainstreaming of witchcraft makes it less taboo for practitioners of witchcraft to be "out of the broom closet," so to speak, then that shift is tolerable. As someone living in a

very politically progressive part of the country, it's easy to forget that there are many places in the U.S. where being "out" as a practicing witch might be highly stigmatized. Many witches have been discriminated against for their views; several even told me stories about fearing their beliefs would be used against them in court, say in divorce proceedings. And in certain parts of the world, women accused of witchcraft are even being tortured and put to death: in Papua New Guinea, for example, women and girls are sometimes beaten and lynched for supposedly practicing *sanguma* (which translates to "sorcery").

Another critical point mentioned by many of my subjects is the cultural appropriation of certain Indigenous practices and terminology, which have been co-opted and mass-marketed to such a degree that not only are the original meanings all but lost, the actual materials necessary for practice have become scarce in the communities that were first to adopt them centuries ago. An example of this is the burning of white sage. If you walk into most New Age shops or apothecaries (or even Whole Foods, for that matter), you'll likely find bundles of dried white sage for sale, the burning of which is thought to have the ability to cleanse and purify. This comes from an Indigenous practice of "smudging," and has become so popular that wild white sage is becoming over-harvested, and the original meaning and derivation of the practice have been watered down or lost entirely. This sort of appropriation can become a kind of theft: a stealing, watering down, and commoditizing of another cultural practice. There's real harm in that erasure and represents a kind of soft colonialism. I've noticed an increased awareness about this, and several shops I know decided to cease sales of white sage accordingly.

I've sometimes worried that *Major Arcana* could be construed as a mainstreaming of witchcraft in that it is helping to bring to the surface something that historically was very much under the radar. But I ultimately believe that the series challenges our assumptions about witchcraft and gives form and voice to the individuals who identify as witches. I've hopefully left viewers with some mystery, too, and questions of their own—I think there's power in that mystery.

HORACE: As I read through the manuscript again on the train, and then again, before coming to your studio on this sunny high-autumn day, I am left with the innate sense that witches think deeply, perhaps seismically, about power in all its manifestations—natural, individual, collective, cultural, divine. The ways power is instrumentalized, weaponized, internalized. Past moments of your practice have explored privilege and the material manifestations of privilege. How are power and privilege different for you?

FRANCES: Whether it's a reflexive power turned inward, toward the self, or a power directed externally, as in a healing modality such as herbalism or midwifery, witchcraft is undoubtedly about the autonomous cultivation of power, and the ability to manifest change or action. This could come in the form of healing from past trauma, negotiating major life changes, or even political activism. As you put it, "natural, individual, collective, cultural, and divine" power. Precisely.

Power and privilege are interconnected. Unlike an inherited, systemic power that, say, male privilege endows, the power conjured by witchcraft is generated wholly by the individual. Not through devotion to a supreme being or force—but by practice, introspection, and in dialogue with the self and others. With that self-sourced power and privilege comes a deeper sense of responsibility. I'm personally aware of my own place of privilege and power as the creator of this series of pictures. I am—quite literally, as our reader holds this book in their hands—making an object of my subjects. As we discussed earlier, I do this with an understanding of the stakes inherent to that process, and with a keen sense of my own responsibility to represent my subjects with dignity and as much of their own agency as possible.

Speaking of responsibility, I'd like to point out that it is a misunderstanding of witchcraft to think hexing and cursing play an integral part in it. In fact, the most oft-quoted section of the Wiccan Rede (Wicca can be seen as the sourcebook of so many derivations of witchcraft these days) essentially means to "do no harm": An Ye Harm None, Do What Ye Will. Truly, I think witchcraft is for doing good,

for yourself and others. Of course, there are those who appropriate witchery with malintent, but in my experience that is not the norm.

HORACE: What questions remain for you after this project?

FRANCES: On a personal note, I get asked sometimes these days if I consider myself a witch, and I actually don't have a straightforward answer. While I relate to the archetype, and clearly have an affinity for it, I don't have a witchcraft practice. However, one of the people pictured in this series likened my process of portraiture as a kind of "priestessing," as she put it—as a way of holding space for others. That interests me—not that I feel qualified to add "priestess" to my résumé just yet!

I am confident about one thing: my Puritan ancestors would be horrified to know that I've chosen to focus my work on witches and witchcraft. Though I see myself as an outsider to witchcraft, I still relate more to the archetype of the witch as a model than to any other traditionally female archetype or rigid notion of femininity I absorbed growing up. I think I've always been looking for models of womanhood and femininity that don't feel restrictive or defer to a patriarchal framework. So perhaps I've already chosen "witch" for myself in a way?

Acknowledgments

To my magical subjects: my gratitude for your willingness to take part in this endeavor knows no bounds. Agreeing to sit for a photographic portrait requires a particular kind of bravery. Thank you for your trust.

Pam Grossman and Horace D. Ballard: thank you for buttressing my work with yours–the result is so much the stronger for it.

My editor, Allison Adler, and the team at AMP: thank you for shepherding this book into the world with skill and grace.

My agent, Meg Thompson, and Ashley Collum: thank you for taking on this project in the early days–Ashley, this volume is without a doubt a result of your initial premonition. And Meg, you might just be the baddest witch of them all.

To the *New Yorker* photo department and Naomi Fry for the first press on the project, which sparked a series of happy events that lead to it becoming this book.

Thank you to Brian Clamp and Raechel McCarthy for championing my photographs in all of their permutations.

To my friends: Maya Krinsky, for always being a perfectly tuned sounding board on which I rely again and again; Cotton Codinha, dearest friend and expert wordsmith; Ann Fessler, for putting eyes on an especially tender, early edit; and for all my photo pals who swung by my studio for their much needed two cents. Thanks also to Charlotte Woolf for being such a sage and steadfast studio assistant, and to Nick Bridges for his file conversions.

To my mother, Joan: now I understand why you wanted to throw me a "period party" under a full moon when I "came of age." (Thanks for not going through with it.)

And lastly to my husband, Joshua. Thank you for all that you do for Virginia and me, for feeding us, for the uncompromising pep talks, and most of all for valuing my work so highly.

About the Author

Frances F. Denny is an internationally exhibited photo-based artist and editorial photographer. Her work is represented by ClampArt in New York City, which has mounted three solo exhibitions of her photographs to date. Frances's editorial clients include the *New York Times*, the *New Yorker*, *ELLE*, and *Architectural Digest*. She is the recipient of a New York Foundation for the Arts Fellowship in Photography, and has won numerous other awards in her field, including "*Photo District News'* Top 30," Lensculture Emerging Talent, Magenta Flash Forward, and Critical Mass. She received a BA from the Gallatin School of New York University, and an MFA from Rhode Island School of Design. Frances lives in Brooklyn, New York, with her husband, daughter, and dog.

Website: francesfdenny.com
Instagram: @francesfdenny

For Virginia

Andrews McMeel Publishing
a division of Andrews McMeel Universal
1130 Walnut Street, Kansas City, Missouri 64106

www.andrewsmcmeel.com

20 21 22 23 24 SHO 10 9 8 7 6 5 4 3 2 1

ISBN: 978-1-5248-5833-9

Library of Congress Control Number: 2020936633

Editor: Allison Adler
Art Director: Sierra S. Stanton
Production Editor: Dave Shaw
Production Manager: Carol Coe

ATTENTION: SCHOOLS AND BUSINESSES

Andrews McMeel books are available at quantity discounts with
bulk purchase for educational, business, or sales promotional use.
For information, please e-mail the Andrews McMeel Publishing
Special Sales Department:

specialsales@amuniversal.com.